# AROUND HEATHROW

## THROUGH TIME

Philip Sherwood

AMBERLEY PUBLISHING

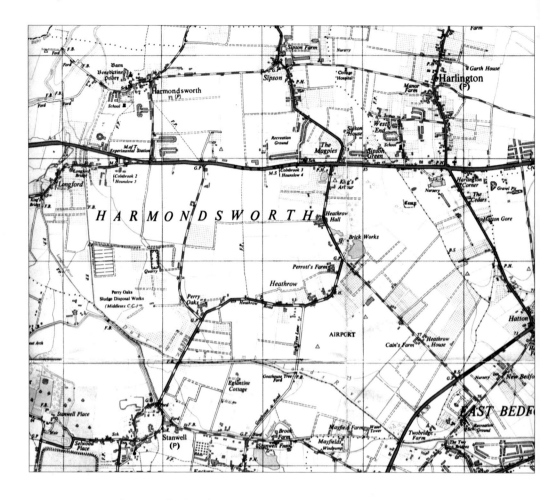

A 1935 OS map showing the hamlet of Heathrow in the centre and the surrounding villages of Stanwell, East Bedfont, Hatton, Cranford, Harlington, Sipson, Harmondsworth and Longford.

First published 2012

Amberley Publishing
The Hill, Stroud
Gloucestershire, GL5 4EP

www.amberley-books.com

Copyright ©Philip Sherwood , 2012

The right of Philip Sherwood to be identified as the
Author of this work has been asserted in accordance
with the Copyrights, Designs and Patents Act 1988.

ISBN 978 1 4456 0846 4

British Library Cataloguing in Publication Data.
A catalogue record for this book is available from
the British Library.

Typeset in 9.5pt on 12pt Celeste.
Typesetting by Amberley Publishing.
Printed in the UK.

# Introduction

Before 1944 Heathrow was a hamlet lying in peaceful obscurity within the parish of Harmondsworth. It was in the heart of an area of Grade I agricultural land given over almost exclusively to market gardening to provide fruit and vegetables to the London market, which did little to disturb the peaceful scene.

All this changed during the Second World War when the decision was made to locate Britain's principal civil airport at Heathrow. The use of wartime powers circumvented the need for a public inquiry. This fraudulent decision took place in secret and could not be challenged at the time because of the alleged urgent need for the RAF to have a base close to London in furtherance of the war effort. There was never such a need, but it is not the purpose of this book to go into any detail of how this came about. The subject has been extensively covered in my book *Heathrow: 2000 Years of History* (revised 2nd Edition, History Press, 2011). Instead, it focuses on the changes that have occurred to Heathrow itself and the villages to the north of the airport, namely Cranford, Harlington, Sipson, Harmondsworth and Longford, over the last 100 years. These are known collectively as the Heathrow Villages, and there can be few areas of the country that have seen such dramatic changes.

There are of course villages - East Bedfont and Stanwell, and their associated hamlets - to the south of the airport and at one time they were united with those to the north. After the Poor Law Reform Act of 1834 they all formed part of the Staines Union, sharing the same workhouse at Ashford (now the site of Ashford Hospital), and until the early 1930s they all came under the jurisdiction of Staines Rural District Council. However, the development of the airport destroyed the north-south road links between them and the large expanse of the airport created a barrier, so that now there is little sense of a shared community interest between the villages to the north and south of Heathrow. For this reason those to the south have not been included in this book.

With one exception, the book is divided into chapters dealing in turn with each of the individual villages. The exception is the final chapter, which deals with farming in the area. The villages share a common agricultural history and many of the farms had land spreading across the whole area. For example Messrs. Wild and Robbins of Sipson Farm farmed on 500 acres in fields situated not only in Sipson but also in Harlington, Harmondsworth and Heathrow. Other members of the Wild family had farms at Longford and Heathrow.

P. T. Sherwood
Harlington, 2012

# Acknowledgements

Many of the photographs reproduced in the text come from my own private collection, accumulated over many years. They include some that have always belonged to me and others given to me, from time to time, by people with their own reminiscences of pre-airport Heathrow. In particular, mention should be made of members of old local farming families, such as the Wilds, Philps, Newmans and Heywards; also of the late John Chinery and the late Josh Marshall who both donated several photos of the Fairey Aviation Company and its connections with Heathrow. Other individuals who have donated valuable material include Justine Bayley, Roy Barwick, Robin Brown, Alison Glenie, Andrew Wood, Ken Pearce, Linda Pocklington, Barry Raymond, Douglas Rust, Peter Shackle, John Walters and Howard Webb. Organisations whose material has been used with permission include the RAF Museum, BAA plc, Hillingdon Borough Libraries, Hounslow Borough Libraries, West Drayton Local History Society (WDLHS), Hayes and Harlington Local History Society (HHLHS) and the *Uxbridge Gazette*. Apologies are offered to anyone whose material has been inadvertently used without acknowledgement.

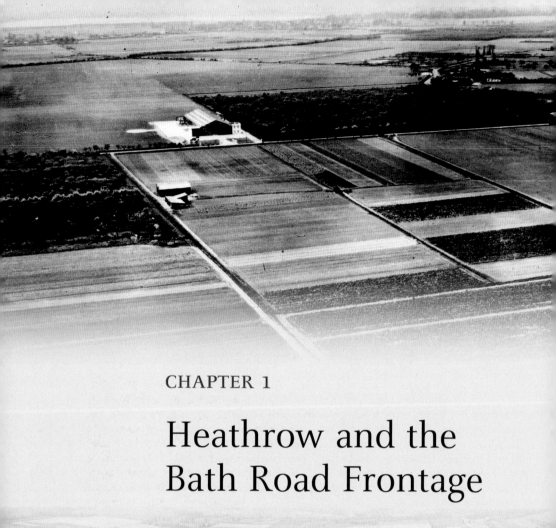

# CHAPTER 1

# Heathrow and the Bath Road Frontage

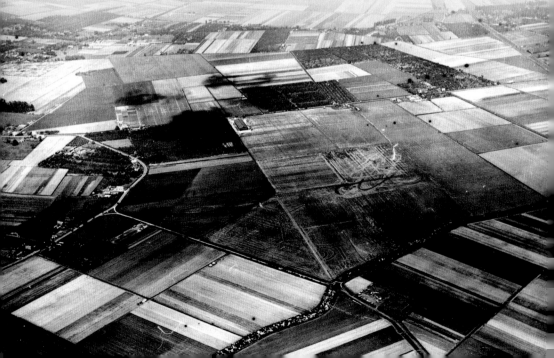

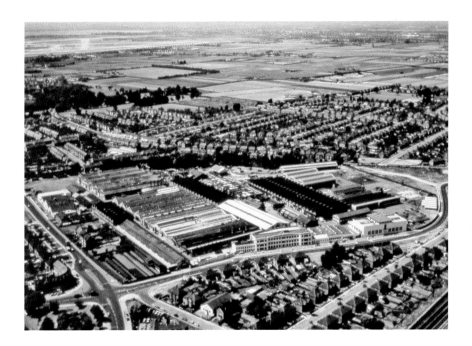

## Where It All Started

Fairey Aviation Company's premises in around 1950. The company was founded in 1915 and shortly afterwards moved to a newly-acquired site in North Hyde Road, Harlington. In 1929 it developed a small airfield at Heathrow for its test flights, which was requisitioned in 1944 under wartime powers to become the nucleus of Heathrow Airport. The view is to the south-west and the airport can just be seen in the far distance. The seizure of its airfield at Heathrow dealt a blow to the company, from which it never properly recovered. It was taken over by Westland Helicopters in 1960, which subsequently moved all its operations to Yeovil in 1972. In 2009 all the remaining buildings on the site were demolished. Nippon Express currently occupies about a third of the site; the remainder is awaiting development.

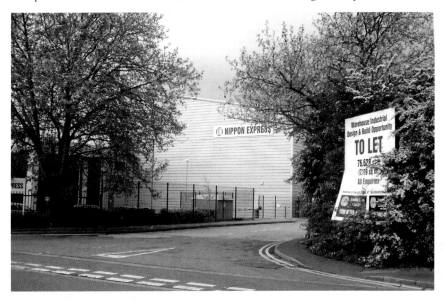

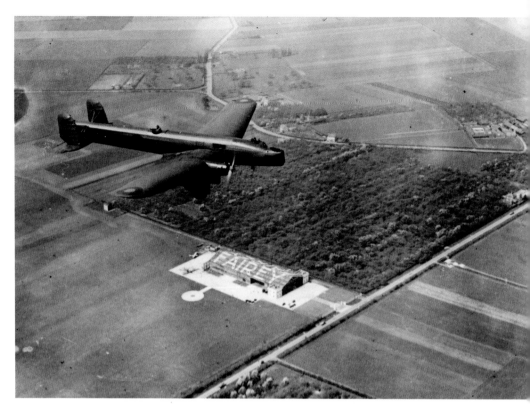

## Cain's Lane

Prototype Hendon bomber flying over the Fairey aerodrome in 1935, with Cain's Lane in the foreground. The hamlet of Heathrow, straggling along Heathrow Road in the background, remains as yet undisturbed. Below we see Heathrow Airport under construction in June 1946. Cain's Lane and Heathrow Road can still just be seen among the devastation.

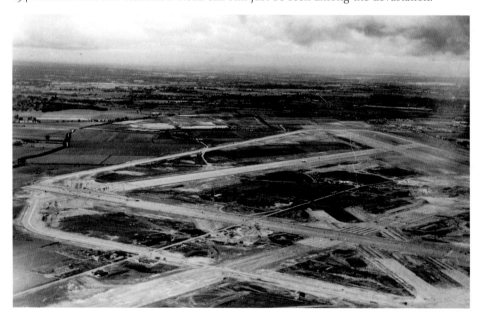

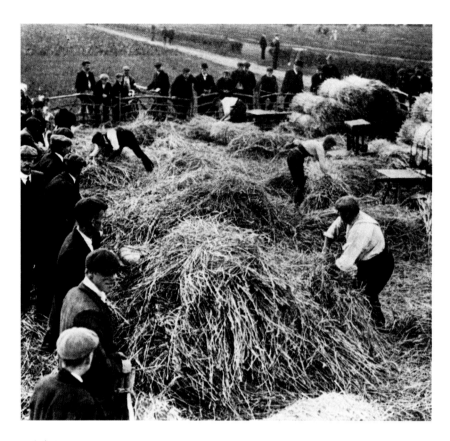

**Cain's Lane**
Scene in Cain's Lane, Heathrow at the Middlesex Ploughing Match, 1908. The ploughing match was held annually in the Heathrow area up to the outbreak of the Second World War. The same area of Cain's Lane is seen below in 1944, showing preliminary work on the construction of the airport.

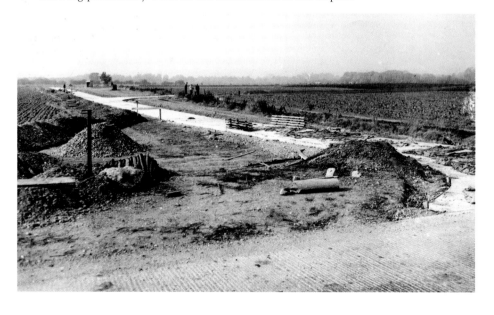

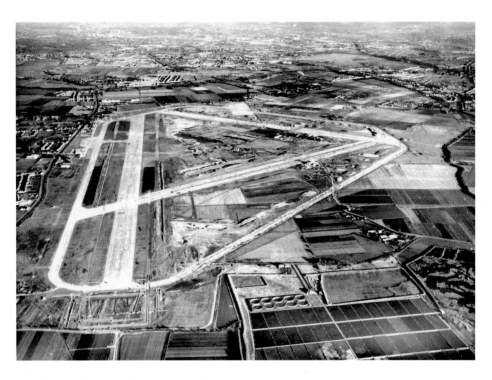

## Heathrow Airport Under Construction

This 1945 view is taken from the south-west with the Perry Oaks sludge works (now the site of T5) in the foreground. (Photograph courtesy of the RAF Museum. Ref. 6082-9) Below we see Heathrow Airport in 1954. The area to the south of the Bath Road had been completely overwhelmed but to the north the villages of Harmondsworth in the right-hand corner and of Sipson (*centre left*) were still relatively undisturbed.

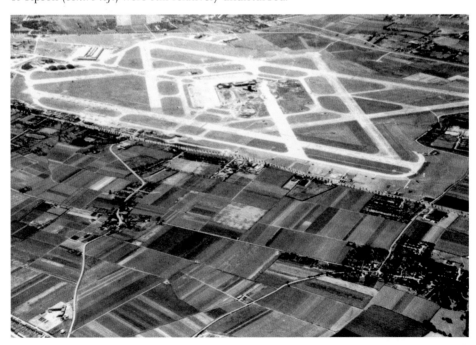

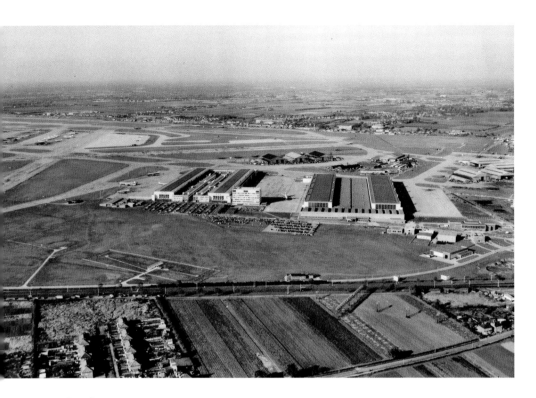

## Hatton Road
The above view of the airport from Hatton Cross 1961 is to the north, with the Great South West Road crossing the lower part of the photograph from east to west and Hatton Road just clipping the lower right-hand corner. The buildings in the centre are the BEA maintenance base. The lower photograph shows an earlier view of the same part of Hatton Road as seen in the previous photograph, this time looking in a north-easterly direction. A Boeing stratocruiser is about to land at the airport.

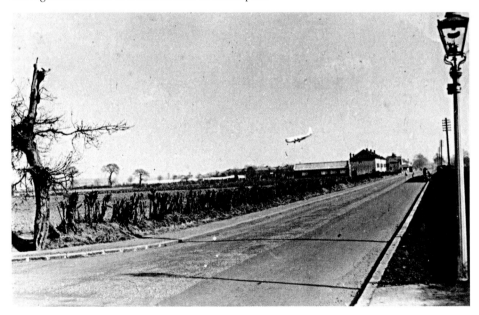

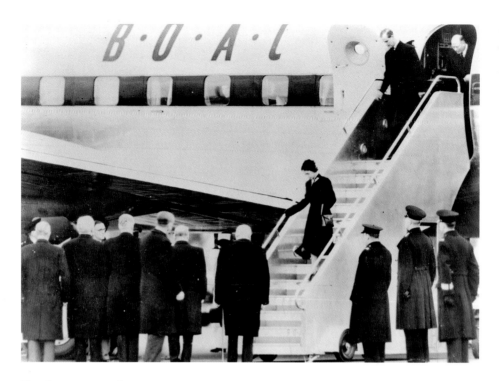

**The Queen at Heathrow**

The Queen arriving back at Heathrow on 7 February 1952, following the death of her father on the previous day. She was met by members of the Privy Council, including Winston Churchill, seen standing at the foot of the steps with Clement Attlee and Anthony Eden standing immediately to his left. She had been on a trip to Kenya and was setting foot on British soil for the first time as Queen. Below, the Queen's Building in 1956, so-called because it had been opened by the Queen in the previous year. It served as an administrative centre and was demolished in January 2010 to make way for a £1 billion renovation of the airport's new Terminal 2.

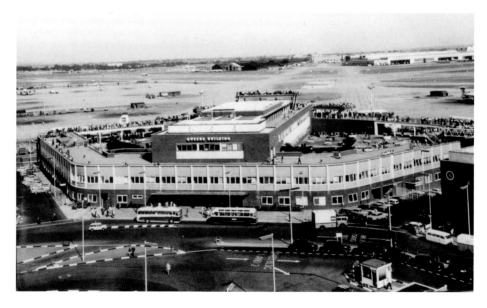

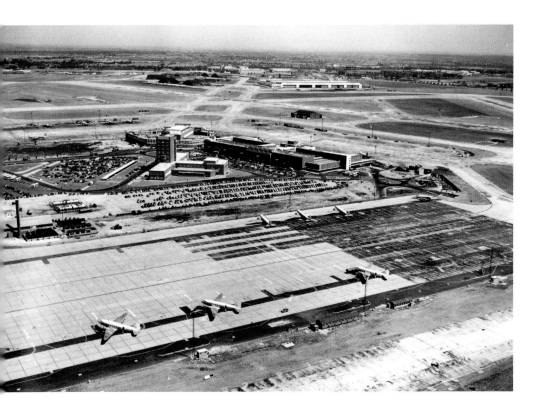

## Central Terminal

Above we see the Central Terminal area in 1961. The view is to the south-east, with the BEA maintenance base in the distance. The aerial photograph below was taken in 1990.

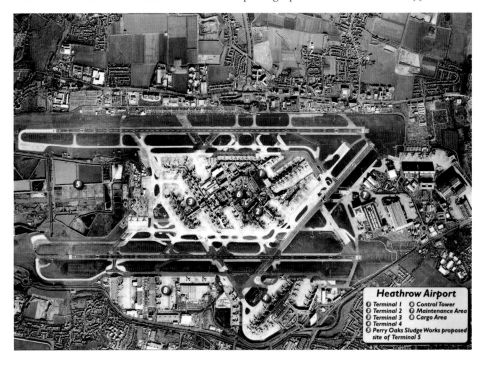

**Heathrow Airport**
1 Terminal 1    6 Control Tower
2 Terminal 2    7 Maintenance Area
3 Terminal 3    8 Cargo Area
4 Terminal 4
5 Perry Oaks Sludge Works proposed site of Terminal 5

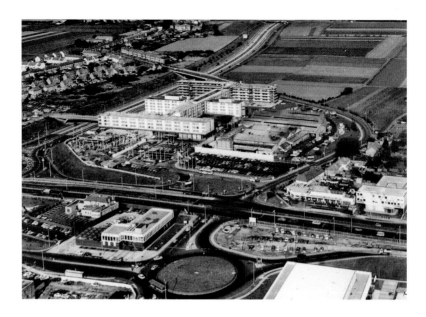

## Heathrow and the M4

In this 1970 image, the Bath Road crosses the picture east to west in the foreground. To the south is the roundabout leading towards the Airport Spur Road. To the north, the large building in the centre of the picture is what the Park Inn Hotel is now and to its left the Spur Road curls away towards the M4 motorway. The M4 and the Spur Road to the airport were opened in the mid-1960s. The later photograph, which shows the junction of the Airport Spur Road and the M4 looking west in around 1990, demonstrates how badly the area was carved up by the construction of the motorways and their subsidiary roads.

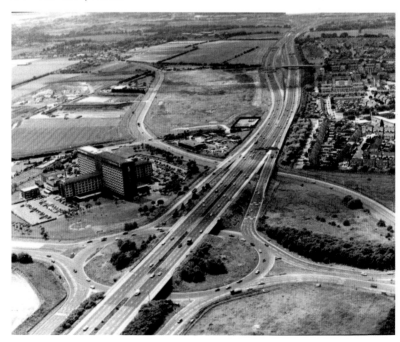

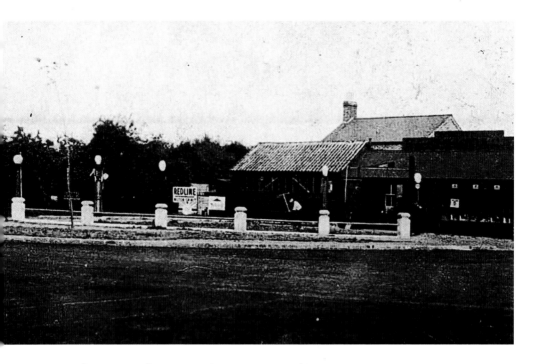

**Great South West Road at Hatton Cross, _c._ 1930 and 2012**

The Great South West Road was constructed in the 1920s as a continuation of the Great West Road to Staines. This photograph shows a petrol station that stood at the north-west corner of its junction with Hatton Road coming from Harlington. Hatton Cross Station now occupies the site of the petrol station, and Hatton Road leads off to the right.

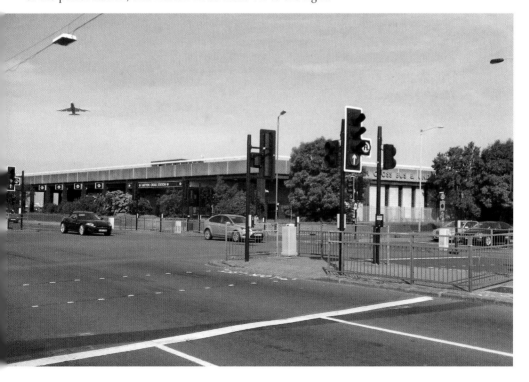

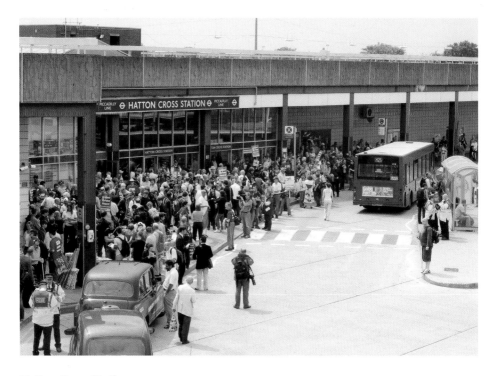

### Hatton Cross Station

Above, Hatton Cross Station in 2008. This was the first station to be opened on the extension to the Piccadilly Line from Hounslow West to Heathrow. It was the first rail link to the airport and not completed until 1976–30 years after the airport opened. The photograph shows demonstrators gathering for a march to protest against the proposed construction of a third runway. Below, the Heathrow Connect Train at Ealing Broadway Station in 2012 The airport had to wait even longer for a link to the main rail network until an electrified line between the airport and Paddington opened in 1997. Two services operate on this line – the Heathrow Express provides a non-stop link with a journey time of 15 minutes while the slower, but much cheaper, Heathrow Connect stops at every station en route.

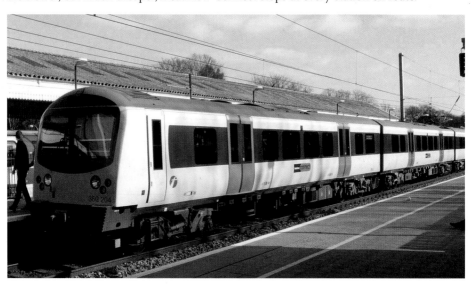

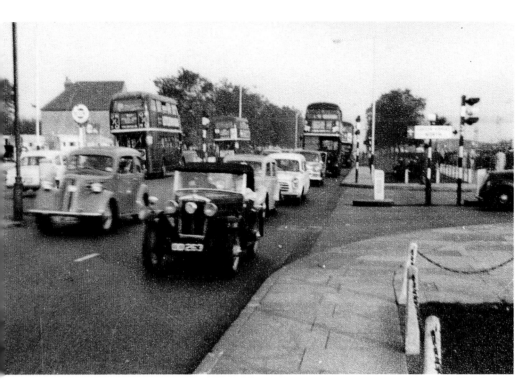

**Entrance to the Airport from the Bath Road** *c.* 1950 and 2012
Comparison of the two photographs gives the false impression that traffic has diminished since 1950. Although the Bath Road has been replaced by the M4 and the Spur Road as main route into the airport, it is usually much busier than this.

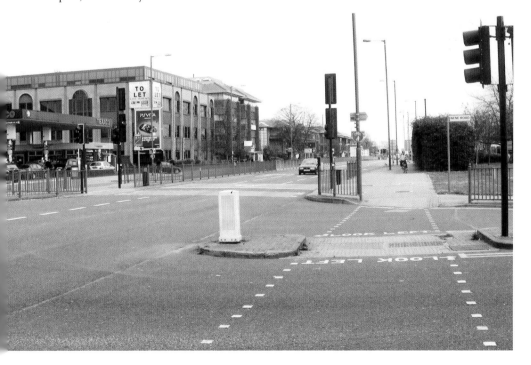

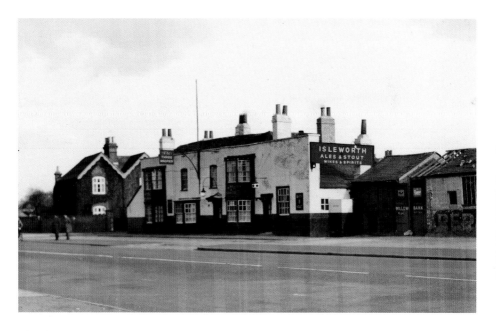

### The Three Magpies, Bath Road, 1944 and 2012

To the left of the old image are the entrance to Heathrow Road and the Doghurst Cottages, which survived until the early 1950s. On the right, the outbuildings of the pub are in the process of being demolished. The pub itself is a remarkable survivor. This eighteenth-century coaching inn, which in 1765 was known as the Three Pigeons, has been extensively restored but it is the only survivor of the many such inns that once lined the Bath Road in the vicinity of Heathrow. The main stopping points for stage coaches en route from London to Bath were Hounslow and Colnbrook, but at least six inns were also established inbetween them. The Three Magpies is also unique in that with its exception every single one of the pre-1944 buildings on the south side of the road between Cranford Bridge and Longford has been demolished.

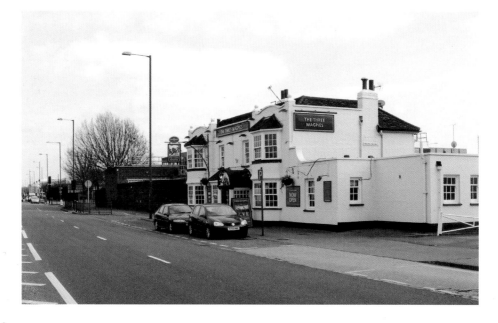

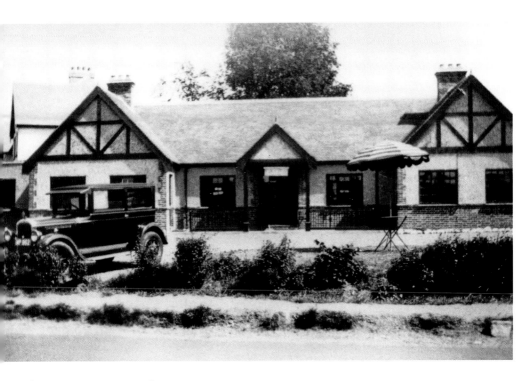

**Sipson Corner, 1930 and 2012**
As motor traffic increased in the 1920s, roadside cafés, such as the one seen here, sprang up on most arterial roads to serve the needs of passing traffic.

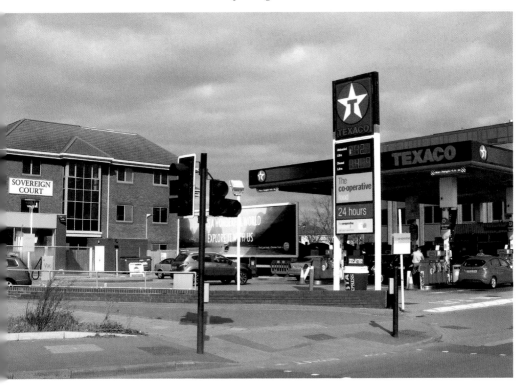

## Bath Road

Former Cottages at the corner of the Bath Road with Bolton's Lane, 1970. These began life as a terrace of Victorian cottages. Some had already had their frontages converted into shops well before the airport arrived on the opposite side of the road, but by 1970 they were all converted to airport-related uses or demolished and their sites redeveloped, as for the office buildings seen in the modern image.

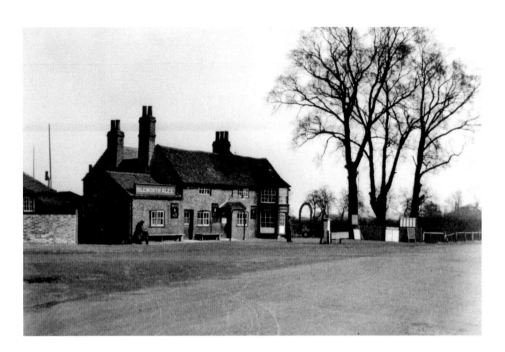

## Harlington Corner *c.* 1920 and 2012
On the left is the Coach & Horses, one of the coaching inns on the Bath Road dating from the eighteenth century. On the extreme right is Ash Cottage, which dated from the mid-nineteenth century. At the time these were the only two buildings on this part of the Bath Road. The Coach & Horses was demolished in 1961 to make way for the hotel seen in the foreground, and the Bath Road is now lined with hotels and offices.

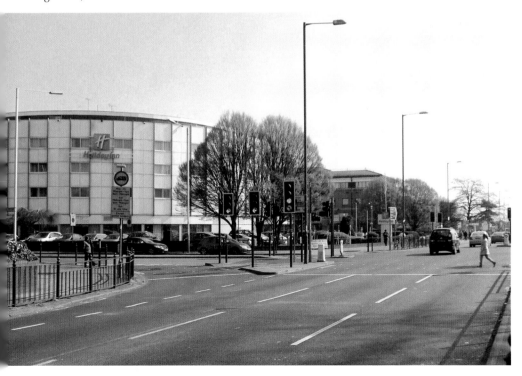

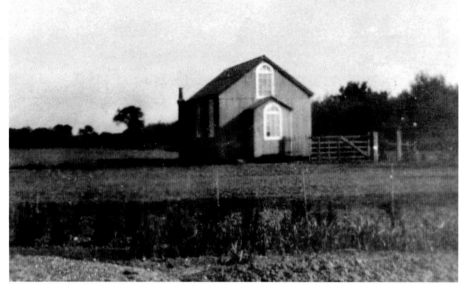

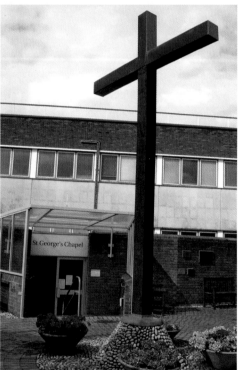

## Churches and Chapels

Above, the Mission Church on Cain's Lane, Heathrow 1935. In 1901 Sipson Baptist Church built this mission hall to cater for the residents of Heathrow. It was made from corrugated iron and typical of the 'tin tabernacles' much favoured at the time by non-conformist churches because of their low cost. It remained in use until 1944 when it was demolished to make way for the airport. Right, the Chapel of St George was dedicated on 11 October 1968 as an Ecumenical Christian Chapel in the central terminal area. The site, in the geographical centre of the airport at the time, was provided by the airport authority and funded largely by the three main Christian traditions: the Church of England (Anglican), Roman Catholic, and Free Churches.

# CHAPTER 2

# Cranford

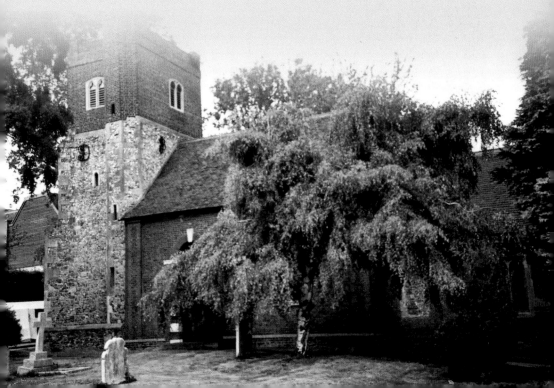

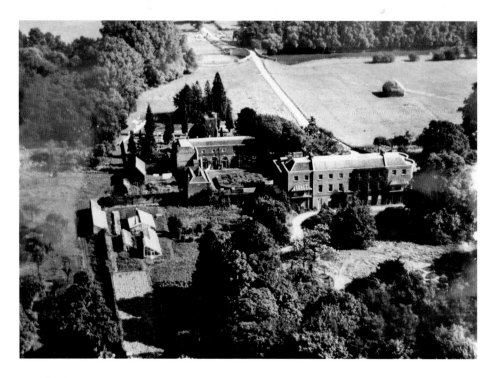

**Cranford House, Early 1900s and *c.* 1935**

The 1935 view (*top*) shows the south elevation of the house, with the stables (which still exist) behind and to the left. The house, of no great architectural distinction, dated from the seventeenth century, with further additions in 1722 and 1792. It was the London home of the Berkeley family, which owned the estate from the seventeenth century until 1918. The house and park were later acquired by the local authority and the house was demolished in 1945.

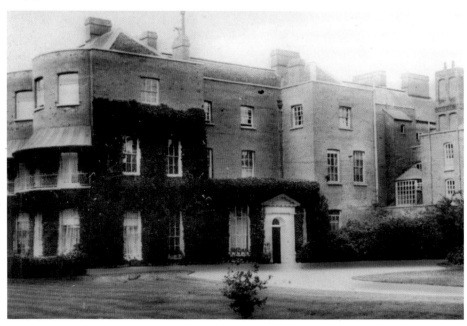

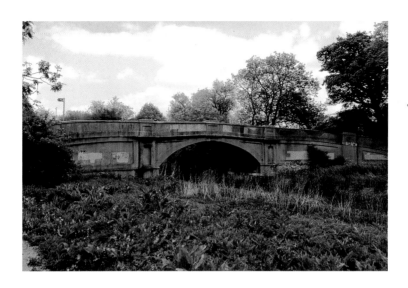

## Cranford House and the Ha-ha Wall

In the above image we see the eighteenth-century bridge, which carries the approach road to Cranford House over the River Crane. The bridge and the ha-ha wall, seen in the lower photograph, are among the few features of the estate that survive today. Such walls form a barrier to livestock but are invisible from the house, thus ensuring a clear view across the estate. They typically consist of a sunken brick wall, its top level with the garden and with a deep ditch on the far side to act as an effective barrier.

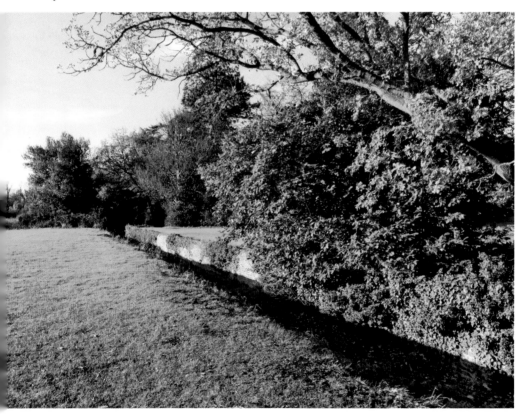

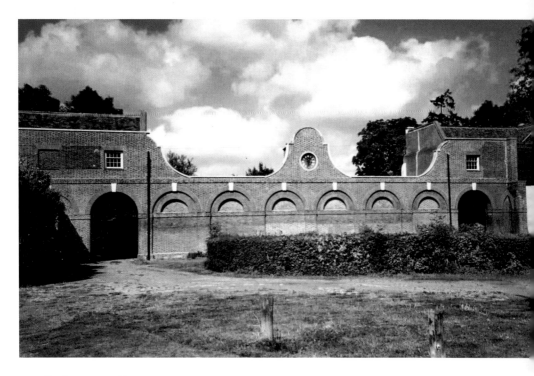

## Cranford House Relics

The stables, which date from the eighteenth century, are the most obvious surviving feature of the estate. The are less aparent, but are an extensive stone and brick Grade II listed feature . They are probably much older than the former house, as it was rebuilt and extended in the 1720s and again in the 1790s.

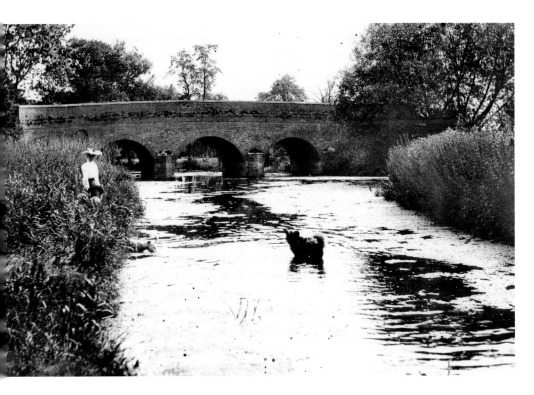

## Cranford Bridge

A bridge to carry the Bath Road over the Crane has existed since the thirteenth century and the one seen here in 1910 was built in 1776 by the Brentford Turnpike Trust. The bridge was rebuilt and widened in 1915 by Middlesex County Council, and widened yet further in the 1950s. The bottom view shows the parapet of the 1950s bridge and a plaque recording its history.

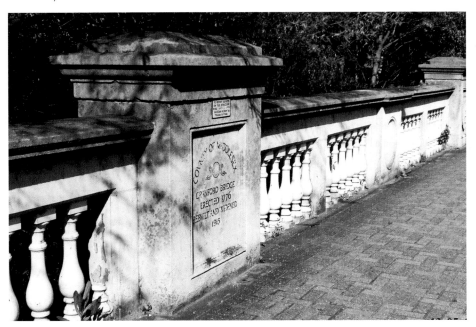

WILLOWS, IN BACKLANE, CRANFORD.

**Bridge in Cranford Lane** *c.* 1920 **and** 2012
For a short distance the road between Harlington and Cranford runs alongside the River Crane before going over the humpback bridge that can be seen in the centre of the photograph. Although the view has not changed for the worse, it is no longer possible to obtain a similar photograph to that seen above because of the growth of the trees in the intervening years.

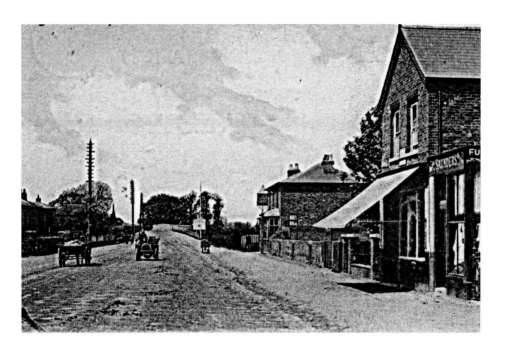

## Bath Road, Cranford

This is Bath Road looking west towards Cranford Bridge in the early 1900s, above, and in 2012, below. Everything has been swept away in the intervening years. Characteristically, on the right a large office building stands vacant, to add to the growing number of empty office buildings around Heathrow, built for a demand that has failed to materialise and is unlikely to do so.

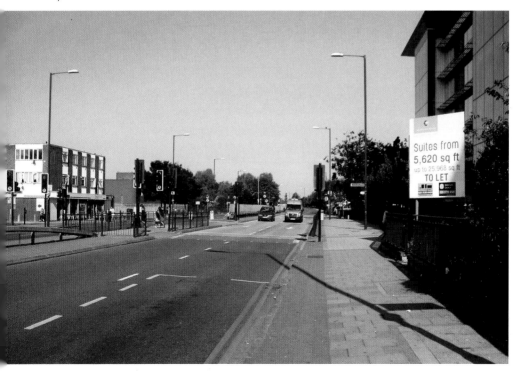

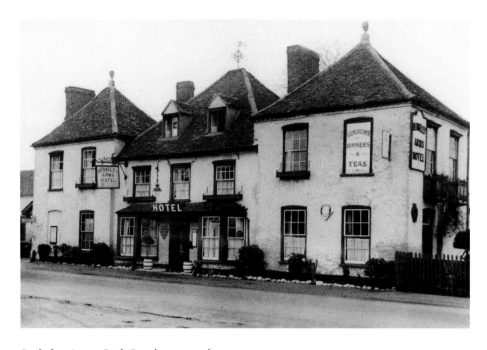

**Berkeley Arms, Bath Road, 1931 and 2012**
This coaching inn on the west side of Cranford Bridge dated from the eighteenth century.
It was demolished in 1931 to make way for road widening and a new pub of that name
built on the same side of the road about 200 yards to the east. This building now forms
the front part of the Ramada Hotel.

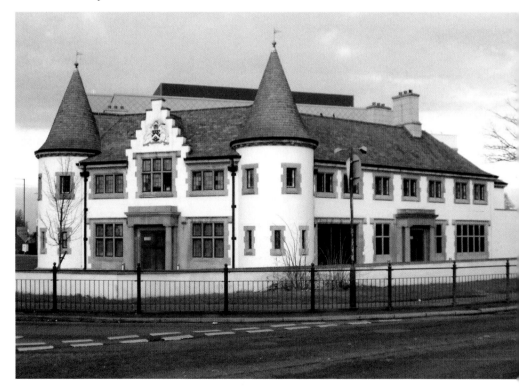

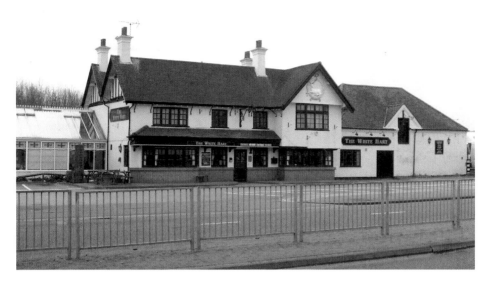

## The White Hart, Cranford Bridge *c.* 1910 and 2011

There had been a coaching inn on this site since the eighteenth century, but the attractive building shown in the modern photograph was built in 1907 to replace the previous inn of that name. On the right are the stables of the original building. All were recently demolished to make way for a fast food outlet seen in the lower photograph, This takes the form of a large concrete box fitted with doors and windows and, unlike its predecessor, is of no architectural interest whatsoever.

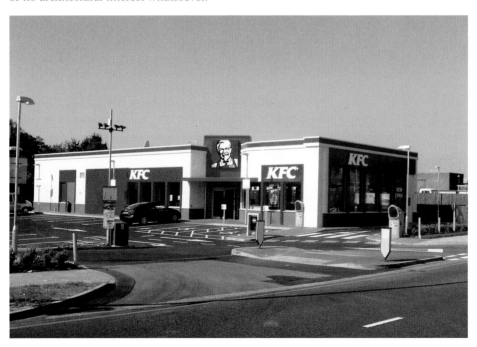

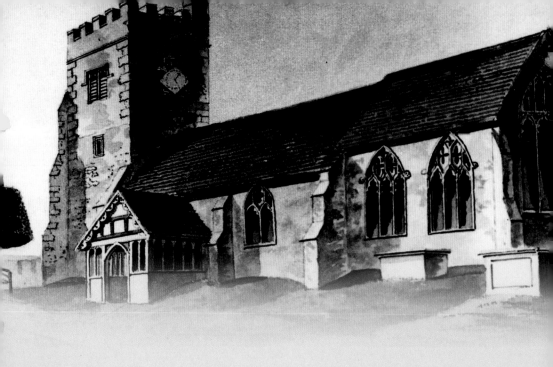

# CHAPTER 3

# Harlington

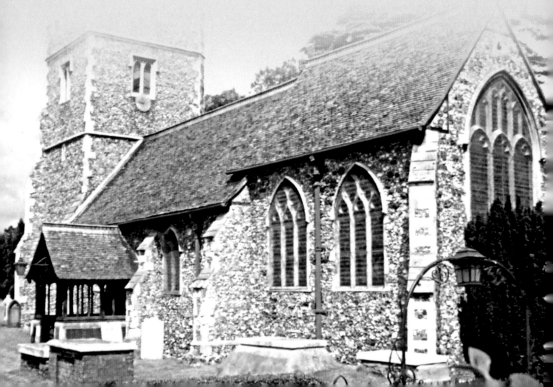

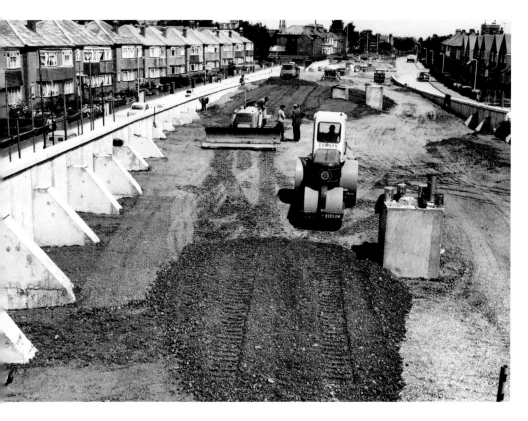

**The M4 and High Street Diversion, 1963 and 1970**
The construction of the M4 motorway in the early 1960s involved the diversion of the High Street so that it went over the M4 and along Bedwell Gardens. The former route of the High Street past the church was re-named St Peter's Way and the remnant of Cherry Lane became St Paul's Close. The aerial view of the diversion was taken in 1970.

**Jessop's Pond *c.* 1910 and 2007**
The pond was situated at the junction of the High Street and Watery Lane just to the south of where the fire station is now sited. It was filled in in the 1930s and its site completely buried under the M4 motorway in the early 1960s.

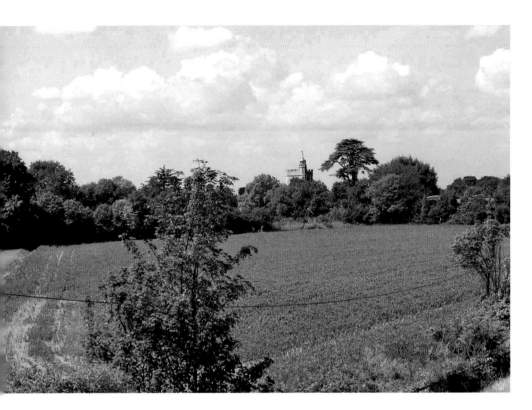

## Harlington Church

The first view of Harlington Church is taken from the motorway bridge. The construction of the bridge opened up a pleasant viewpoint for travellers coming into Harlington from Hayes. Unfortunately the view awaiting the traveller at the bottom of the bridge from the realigned High Street is quite different (*below*).

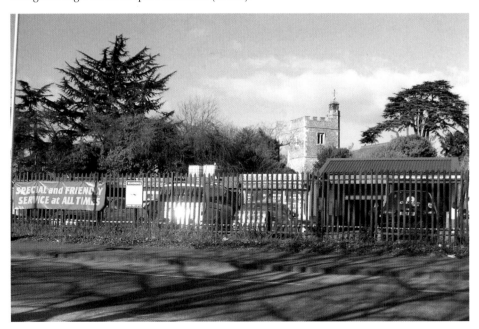

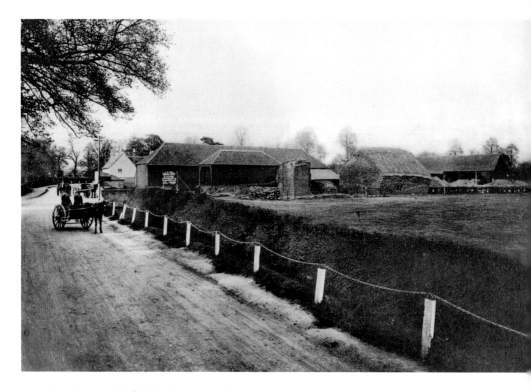

**Northern End of High Street, 1906 and 2004**

The building in the distance is Dawley Manor Farm, which was demolished in 1962 to make way for the M4 motorway. As the M4 motorway cut the old High Street in half, the road, now renamed St Peter's Way, has become a cul-de-sac, as shown in the 2004 image. On the left is the junction with Cherry Lane, which is now also a dead end and has been renamed St Paul's Close.

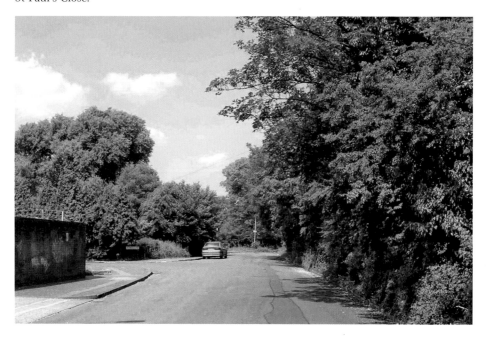

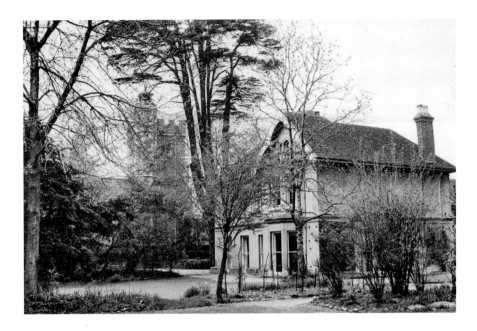

**Harlington Rectory 1968 and 2006**

Parts of the old Rectory, on the north side of the church, dated from the sixteenth century, but the main front part, shown here, was an attractive Victorian building. The rectory was demolished in 1970 and its extensive ground turned into a housing estate, which did irreparable damage to the former peaceful setting of the ancient parish church. A new church hall, built to replace the old one in St Paul's Close, now occupies the site of the old rectory.

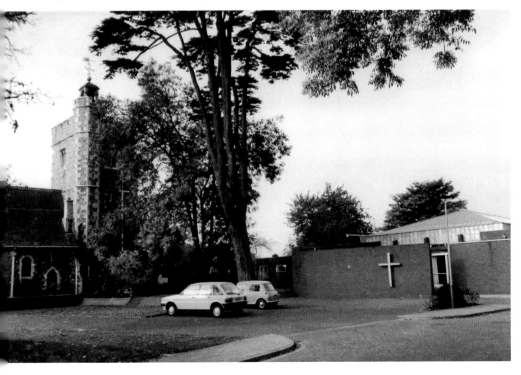

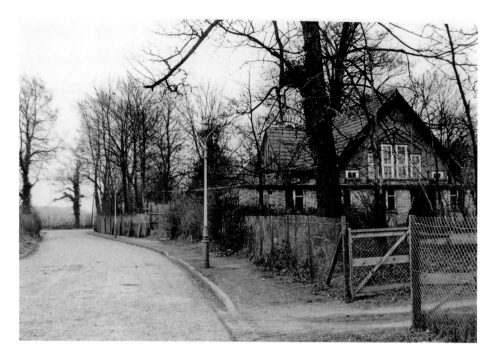

**Cherry Lane and St Paul's Close**
This church hall was built in the grounds of the rectory in the early 1900s and was replaced in the 1970s by the new church hall on the former rectory site, seen on the previous page. The existing church hall was demolished and these barrack-like houses were built in its place as part of the development of the rectory garden.

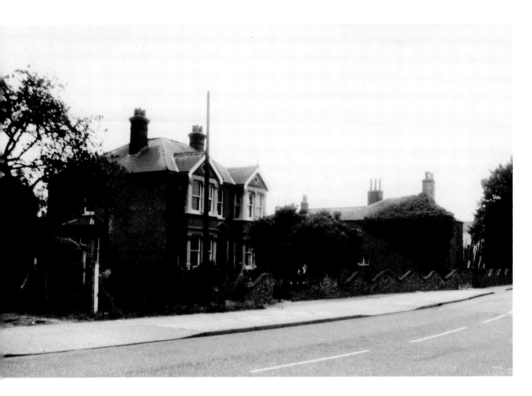

**Bletchmore and Veysey's Farm, High Street, 1970 and 2012**
The houses with large gardens that once lined the High Street, such as the two seen here, were demolished in the 1970s and their gardens developed as the housing on Bletchmore Close. The modern photograph was taken on the High Street, looking south.

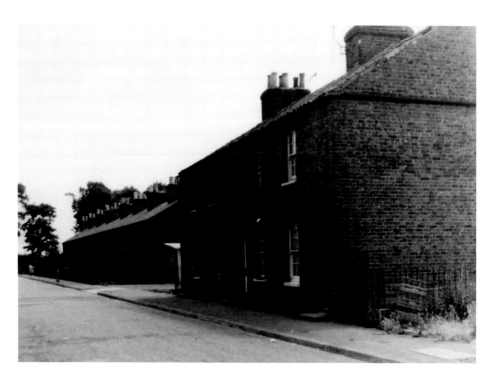

**Brickfield Lane, 1958**

These cottages were on the south side of the road. In the foreground are White Hart Cottages, which dated from the mid-nineteenth century and were demolished in 1960. Those in the background are Lansdowne Cottages, which were built in 1878 and demolished in the early 1970s. They were replaced by the houses seen in the lower photograph.

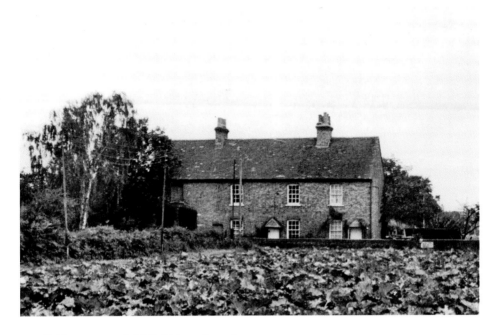

**Eastfield Cottages, Brickfield Lane in 1967**
The open fields of Harlington were enclosed in 1821, but these cottages, which dated from the mid-nineteenth century, took the name of one of the pre-enclosure fields. The cottages were demolished in 1970. Instead, the modern image shows Westfield Cottages on Sipson Lane in 2009. This attractive pair of cottages built in 1847 perpetuates the name of another of the original open fields.

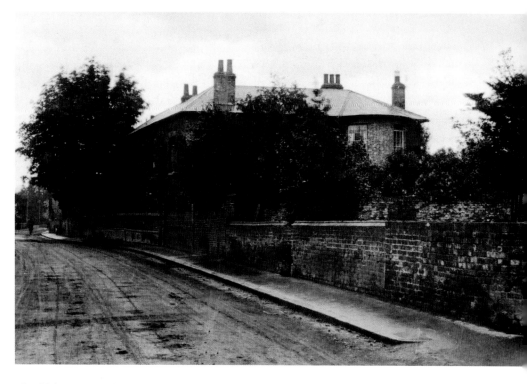

**Shackle's House, High Street *c*. 1920**
This large house, standing in its own grounds, dated from the early 1800s, and had no name other than that of its owner. It was demolished in the 1960s and replaced with the houses in Pembury Court, seen in the lower photograph on the right and partly hidden.

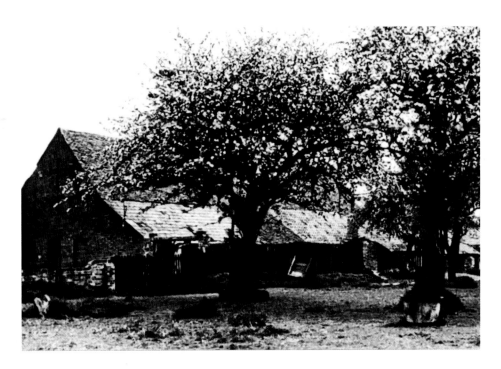

**Shackle's Barn, 1946**

This barn stood in the grounds of Shackle's House and dates from the early 1800s. It was donated to Harlington Scouts by Charles Shackle and after some interior modification has now become their HQ. The scout troop is known as the 1st Harlington Scouts (Shackle's Own) to acknowledge the generosity of the donor.

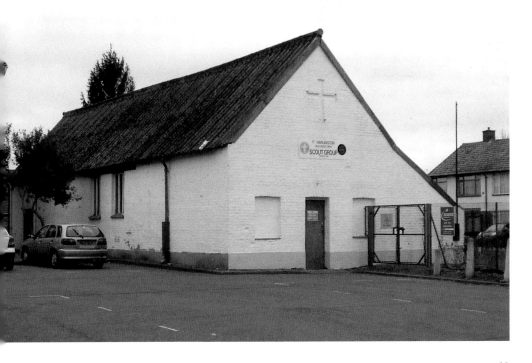

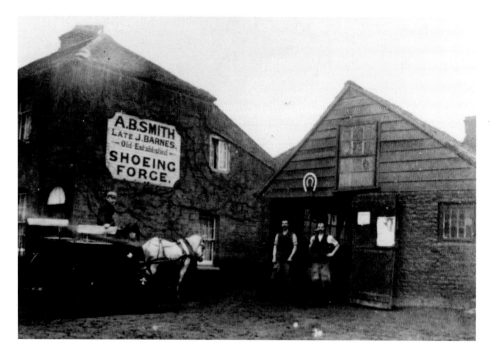

**The Forge, High Street c. 1910**

At one time most villages had a blacksmith, Harlington was no exception and this one continued in use into the 1960s. The buildings survived for some years, but were eventually to make way for the flats seen in the lower photograph, which are collectively known as The Forge.

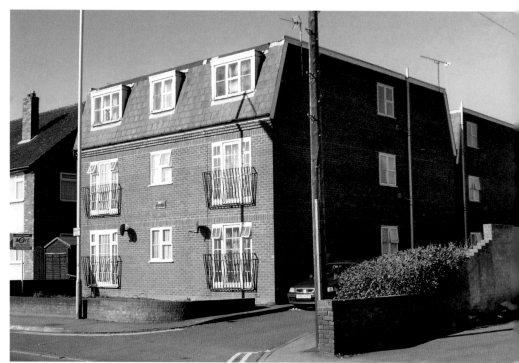

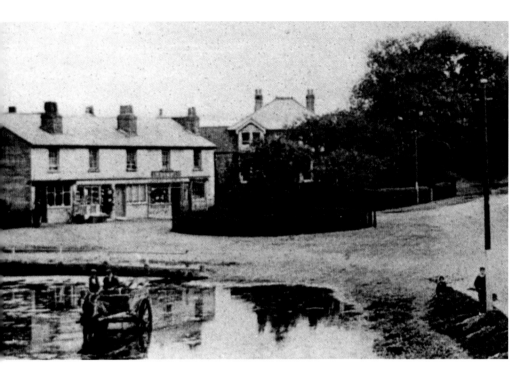

## Harlington Pond, Chapel Row and Manor Farm *c. 1910*

The circular area in the centre had formerly been the site of the village lock up and cattle pound. The pond was filled-in in the 1960s, and to commemorate the Queen's Silver Jubilee in 1977 the sites of the pond and cattle pound were landscaped to form what has become in effect the village green. Manor Farm was demolished in the 1930s and the shops in Manor Parade built on the site. The houses in the foreground occupy the same alignment as Chapel Row, which was demolished to make way for them.

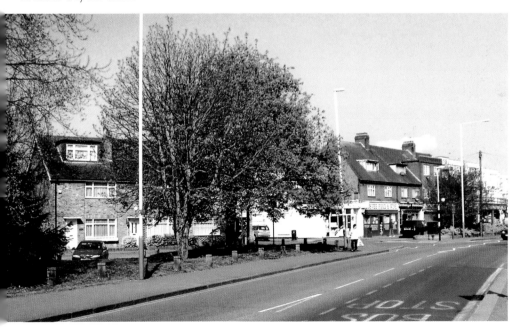

## Barn at Manor Farm

The eighteenth-century barn of Manor Farm survived the demolition of the farmhouse and continued in use for various activities By the 1970s it was in a ruinous condition, as shown above, but was saved for posterity by a sympathetic conversion to office accommodation.

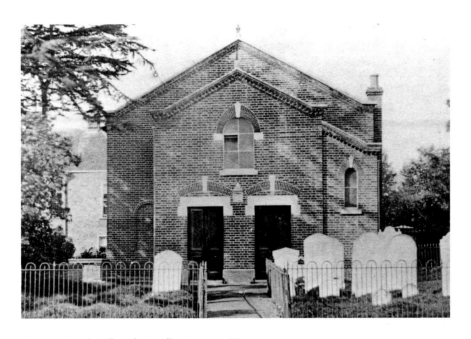

**Former Baptist Church, Harlington, *c.* 1880**

The back part of this building dates from 1770 and the congregation became a Baptist community in 1797. As the congregation increased it was enlarged from time to time until in 1879 the Baptists decided that they needed more space and moved to a new site across the road. Since then it has been used by the church for its Sunday School and it also serves the function of a church hall. The building is still instantly recognisable, but as you can see the entrance has been modified and the tombstones placed against the wall.

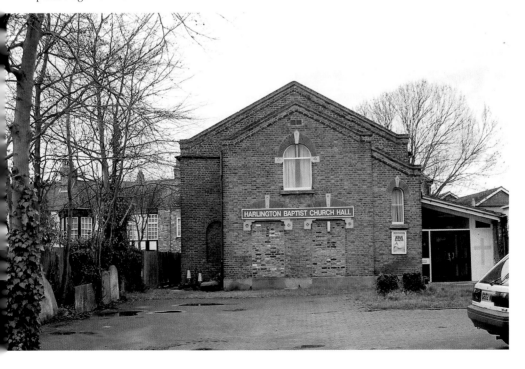

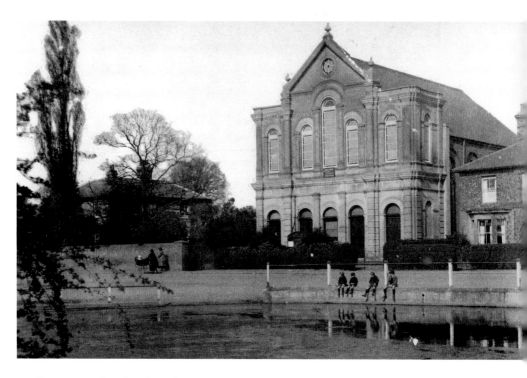

**Harlington Baptist Church and Manse, *c.* 1920 and 2012**
This building, which is Grade II listed, was built as a replacement for the old Baptist church in 1879. The 1920s view is from across the pond. The large house on the left is Poplar House, demolished in the 1960s to make way for Felbridge Court, which can just be seen in the modern image. The church and manse are essentially unchanged.

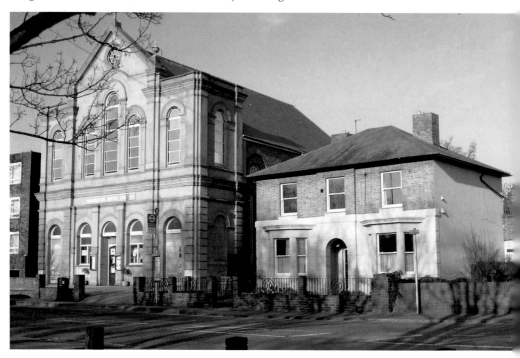

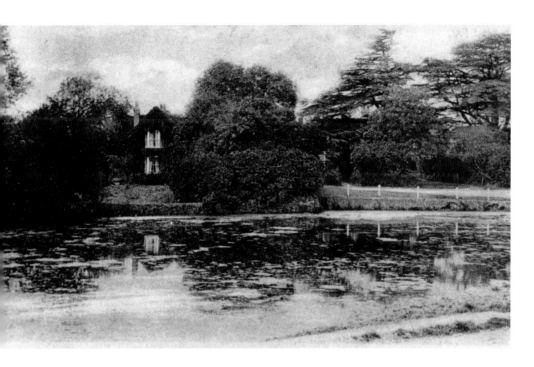

**Harlington Pond, *c.* 1900 and 1967**

The pond, which can be seen in the early photograph, was filled-in in the early 1960s and now serves the function of a village green. The house on the left was called The Lilacs. It dated from the sixteenth century and was reputed to have been the home of William Byrd, the Elizabethan composer who lived in Harlington between 1577 and 1592. The Lilacs was pulled down a few weeks after the 1967 photograph was taken, but the eighteenth-century cottages in the centre of the picture and the old Baptist church on the right have survived with little change in their appearance.

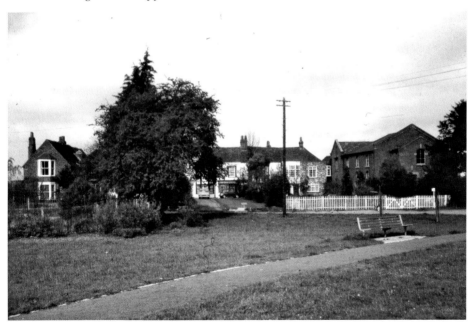

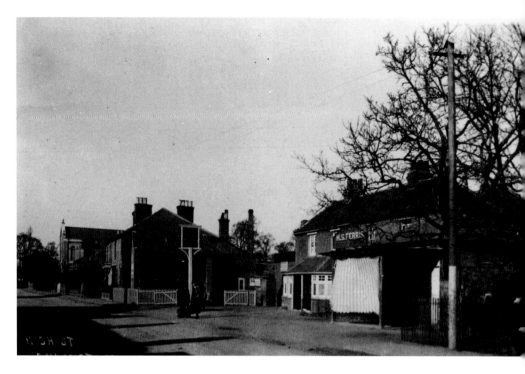

## Harlington High Street

Two views of the High Street from outside the Wheatsheaf looking north: Above, in the early 1900s, with Ferris's butcher's shop, the original Wheatsheaf and the Baptist church in the distance; below, in 2012. Providence Court in the foreground was built on the site of the original Wheatsheaf.

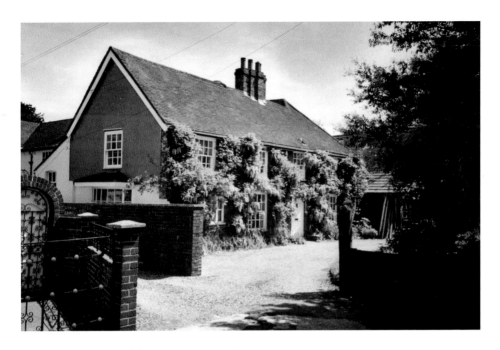

**The Dower House, High Street, 1990 and 2011**

This is (or was) the oldest building in the High Street. It dates from the early sixteenth century with later additions. It is timber-framed with a brick fronting that was added later. At the time of the photograph it was in good hands with an owner who cared for the property. Unfortunately it was the subject of an arson attack in May 2011. Although it is Grade II listed its future remains very uncertain.

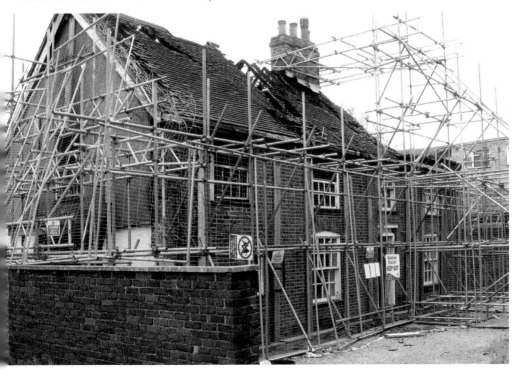

# CHAPTER 4

# Sipson

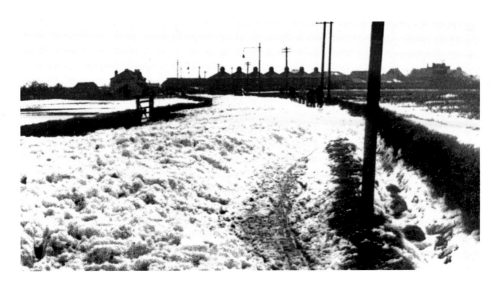

## Sipson Road

The top image shows Sipson Road after a freak blizzard in March 1952, and the comparative isolation of the village at that time, cut off by the snow from its link with West Drayton. The Plough, seen on the right of the picture, is the first building at the extreme northern end of the village and dates from the mid-1800s. It is one of Sipson's two remaining public houses.

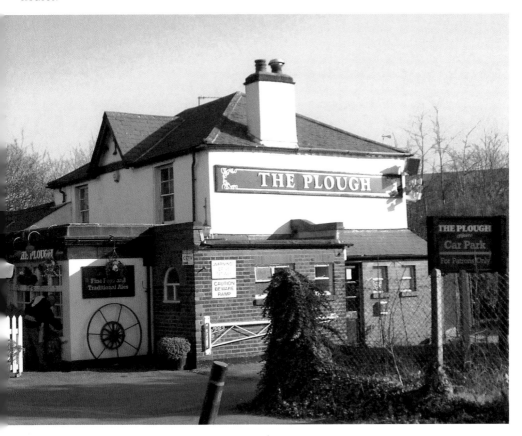

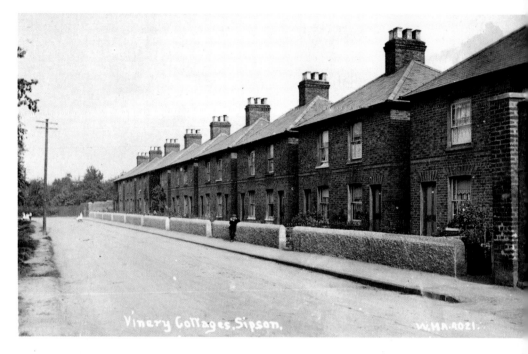

### Vinery Cottages, Sipson Road, Early 1900s

This row of nine pairs of cottages was known locally as the eighteen row. They stood next to the Plough, and were built in 1878 to house some of the farm workers attached to Sipson Farm. The pair furthest from the camera suffered severe bomb damage in 1940 and had to be demolished. The remainder were pulled down in the 1950s. These modern houses in Sipson Road, built on the site of Vinery Cottages, are overshadowed by a monstrous airport hotel.

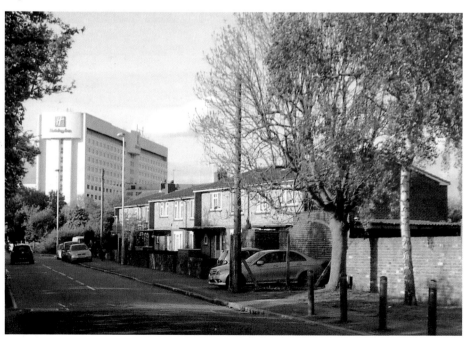

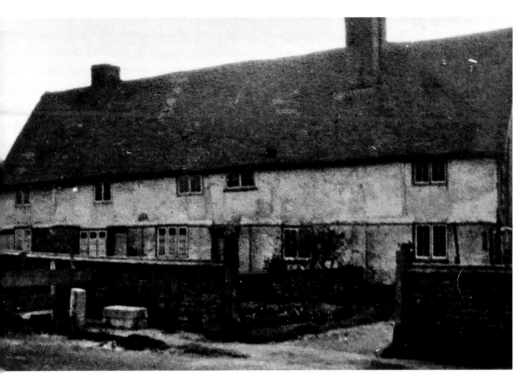

### Sipson Road

Seventeenth-century cottages in Sipson Road just before their demolition in 1933. They stood next to the King William and were replaced by the 1930s houses seen in the photograph below.

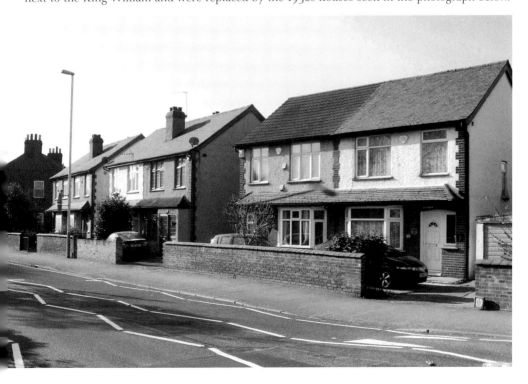

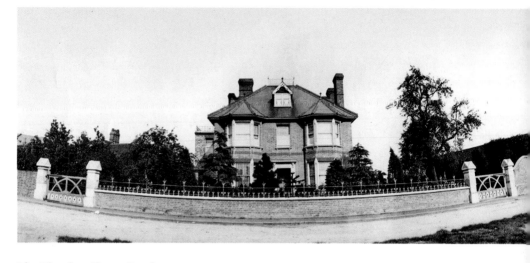

## The Vineries, Sipson Road *c.* 1900

The photograph was taken with a fish-eye lens, which exaggerates the curvature of the road. The house was built in the 1880s for Thomas Wild (1842–1932) whose family had lived in Sipson for at least the previous 300 years. The old house, which had been their ancestral home, can just be seen on the extreme right. With his partner R. R. Robbins he founded Wild & Robbins, which farmed extensively on the land in and around Sipson. The house was demolished in 1970 and the houses in Vineries Close now occupy the site. The modern view is from the same position as above. The front garden wall of the Vineries still exists but it has lost its iron railings and the height has been raised. An original gatepost is still intact on the extreme right..

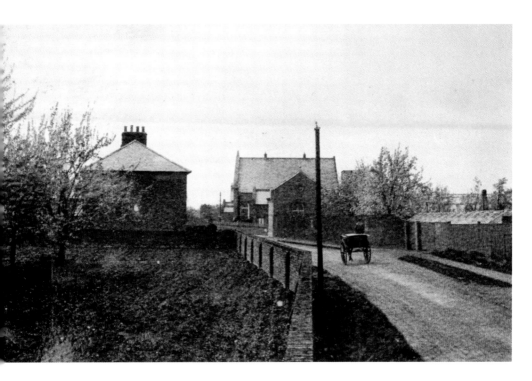

**Entry into Sipson Village from Sipson Lane**
The same view is seen above in 1910, and below in 2007. Only the Baptist chapel on the corner of
Sipson Lane/Sipson Road and the curvature off the road show that this is indeed the same scene.

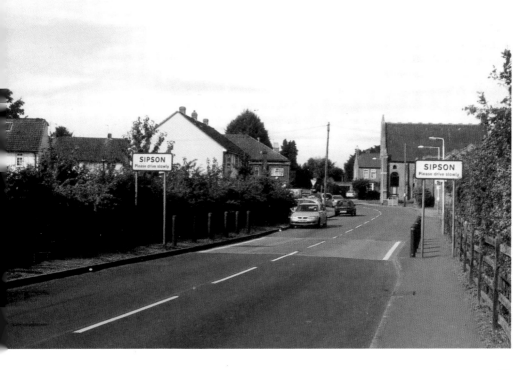

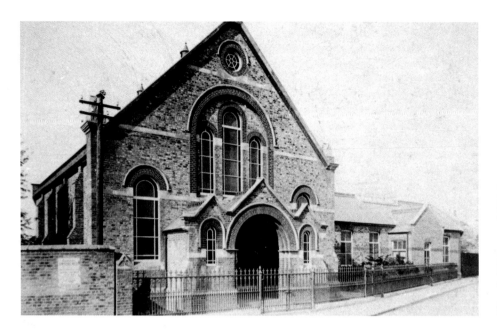

### Sipson Baptist Church, Early 1900s

The church was built by the Wild family in 1891 and enlarged to its present size in 1901. It started life as a Salvation Army hall, became a Gospel Mission hall in 1897 and ended up as a Baptist church in 1905. The Baptist church remained in use until the mid-1980s but the major part of the building was then converted to residential accommodation and renamed Church Court. The far end, formerly the Sunday school, is still used for religious purposes. The external view is largely unchanged.

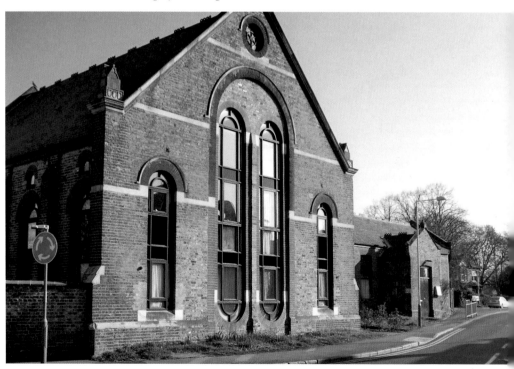

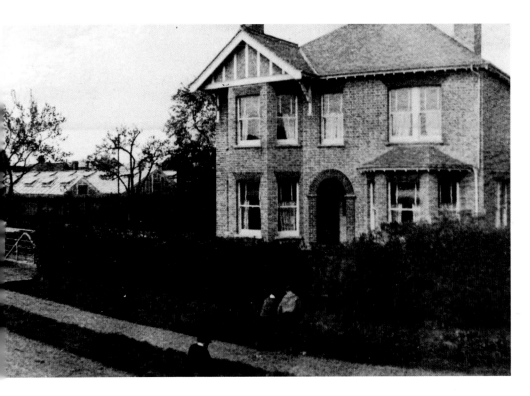

### Inglenook, Sipson Lane, Early 1900s
The house was built for Thomas Wild junior on his marriage to Elizabeth Rayner. On his father's death he moved into the Vineries, while his son, also named Thomas, moved with his family into Inglenook. In 2012 the house is largely unaltered but it is now used as a children's day nursery.

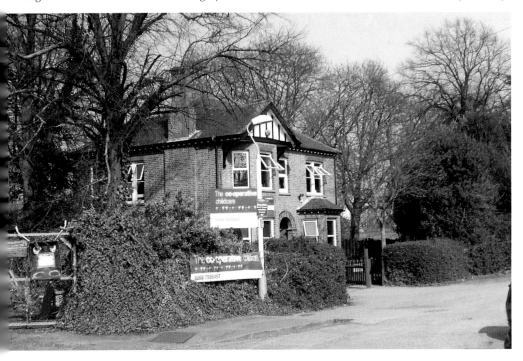

## Hollycroft

This rear view of Hollycroft was captured in around 1920. The eighteenth-century house in Sipson Road was the home of R. R. Robbins, the co-founder of Wild & Robbins, from 1900 to 1948. It was demolished in the 1960s and the houses in Hollycroft Close now occupy the site.

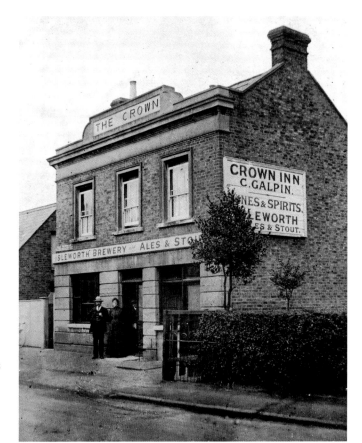

### The Crown

This mid-Victorian pub is opposite the post office in the middle of the village. The two people standing outside in the early 1900s are the landlord C. Galpin and his wife. Like many others in recent years it has since ceased to be a public house, but the building at least survives intact and is now the Zayani Indian restaurant.

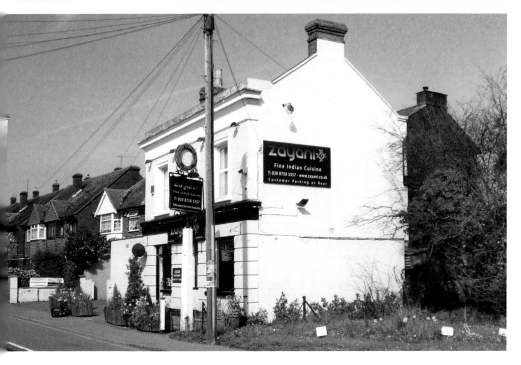

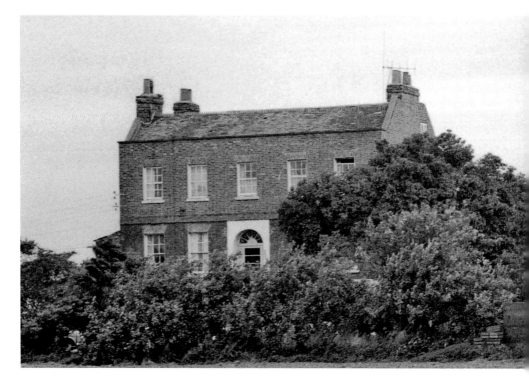

**Sipson House in 1966**

The attractive Grade II listed eighteenth-century building stands back from the main road. It fell into disrepair in the early 1970s and permission was given for its restoration and conversion to office accommodation. It apparently still survives under its new name of Sipson Court, virtually intact except for the addition of two wings on either side. However, the so-called 'restoration' involved the demolition of the entire building apart from its front façade, so it is now little better than a neo-Georgian replica.

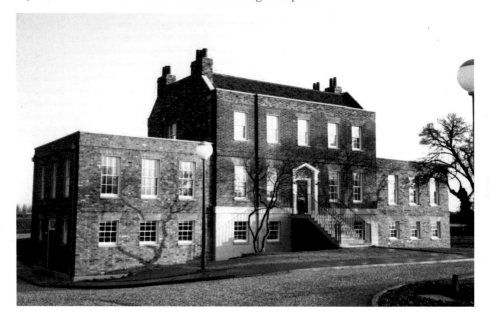

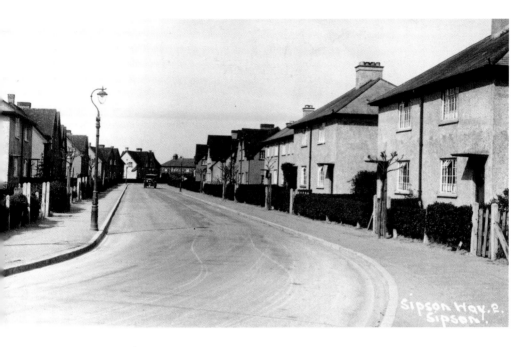

## Sipson Way, 1935 and 2008

The larger houses in the distance date from in 1923 when Sipson Way was built to provide a short cut between Sipson Road and the Bath Road. The houses in the foreground were built a few years later. The later photograph was taken on the occasion of a protest demonstration against a proposed third runway at Heathrow, which would have led to the destruction of Sipson. The protest march had begun at Hatton Cross Station and ended up in the recreation ground in Sipson Way.

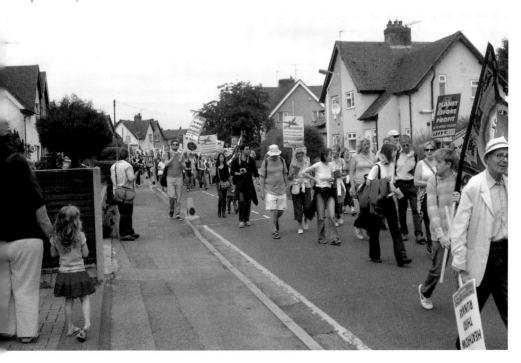

### Recreation Ground, Sipson Way

Below we see the opening ceremony of the recreation ground in Sipson Way in 1932. Its official title is the Harmondsworth War Memorial Recreation Ground, as it was opened as a memorial to the men of the parish of Harmondsworth (which includes Sipson) killed in the First World War. The man addressing the audience is Cllr Dominey, the chairman of the local council. Above, celebrations in the recreation ground followed the cancellation of the plans to construct a third runway at Heathrow in August 2010.

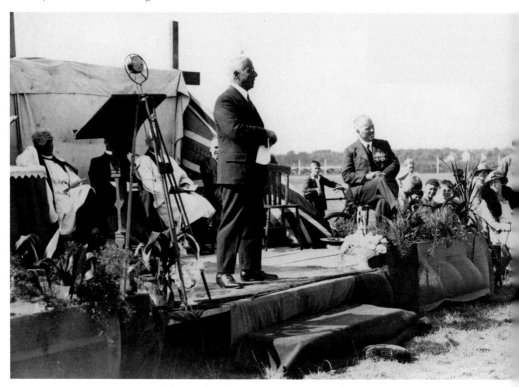

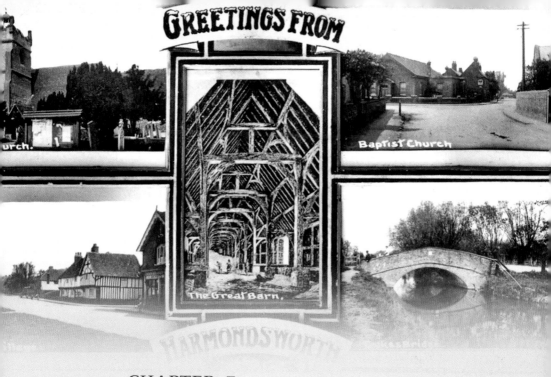

# CHAPTER 5

# Harmondsworth

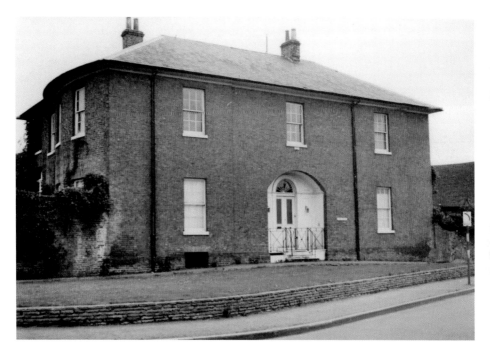

## The Lodge, 1967 and 2012

This Grade II listed building dates from the early 1800s and occupies a prominent position at the junction of the roads from Sipson and West Drayton. When the photograph was taken it was derelict and faced an uncertain future, but soon afterwards it was converted to office accommodation.

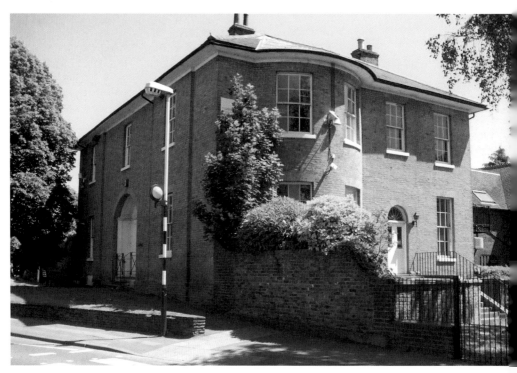

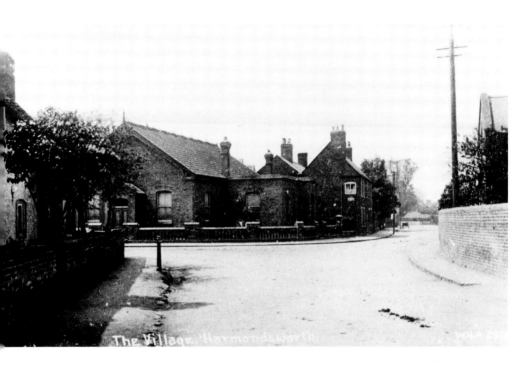

## Harmondsworth Village

The entrance to Harmondsworth village from Sipson and West Drayton in the early 1900s and in 2012. All the buildings seen on the left of the earlier photograph have survived. The main building in both is Harmondsworth Baptist church, which dates from the 1890s.

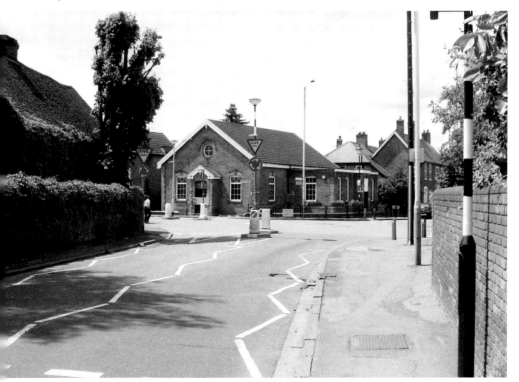

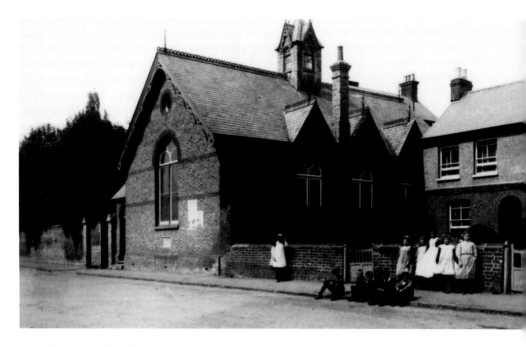

### The Vicarage Hall, Early 1900s

The vicarage hall was built in the grounds of the vicarage. The view is to the south with Howcroft, a Grade II listed building, just in view on the right. The building was demolished in the 1970s and replaced with a new hall in the churchyard, attached to the north side of the church. All that remains of the original hall is the lower half of the front wall and the foundation stone. Howcroft and the former vicarage can now be clearly seen.

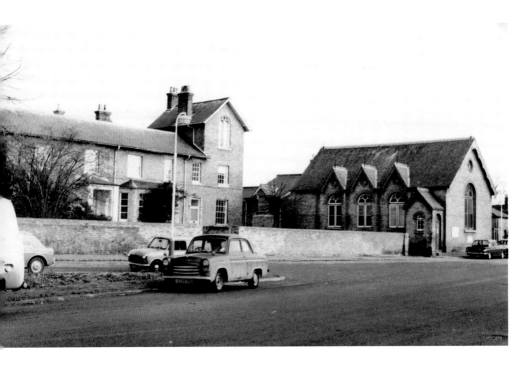

### The Vicarage and Vicarage Hall *c.* 1970

The hall as viewed from the other side. The foundation stone, which still exists, can be seen just beneath the front window. To the left of the hall is the former vicarage, which dates from 1845. Still used for its original purpose when the photograph was taken, it is now a day nursery. Below we see St Mary's Church Hall in 2012. This utilitarian building was built on to the north side of the church as a replacement to the vicarage hall.

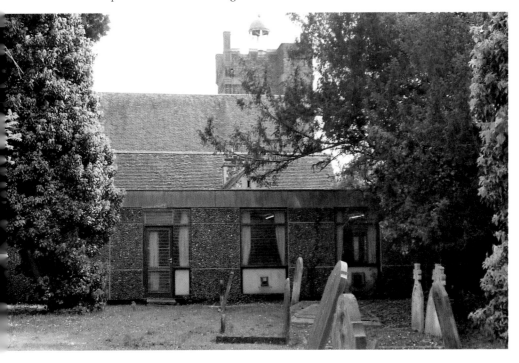

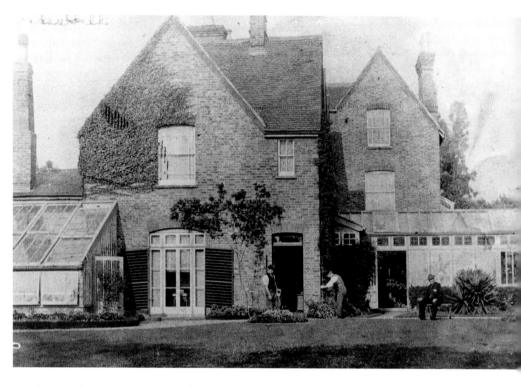

**Cambridge House, Rear View, Early 1900s**
This early nineteenth-century house stood in a large garden next to the Crown. It was demolished in the early 1960s and the houses in Cambridge Close, shown below, now occupy the site.

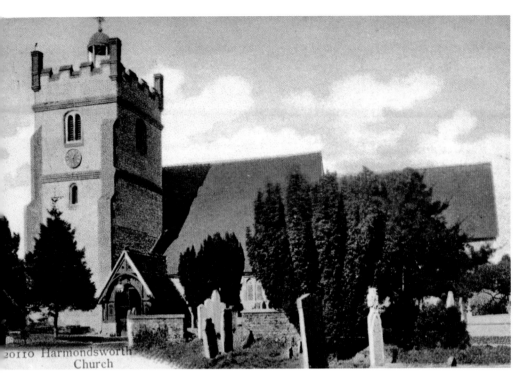

20110 Harmondsworth Church

**Harmondsworth Church, 1900**
Like its neighbour at Harlington, the church dates from the twelfth century and possesses a fine Norman doorway. Although the church has not changed in appearance since then, the trees have grown to such an extent that only the tower can be seen from the road. Below, anti-airport propaganda mocks the hypocrisy of BAA's commitment to support local community projects that mitigate against the airport's impact while at the same time seeking to build a third runway that would have made Harmondsworth uninhabitable.

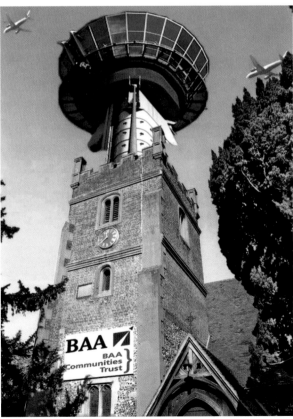

BAA
BAA Communities Trust

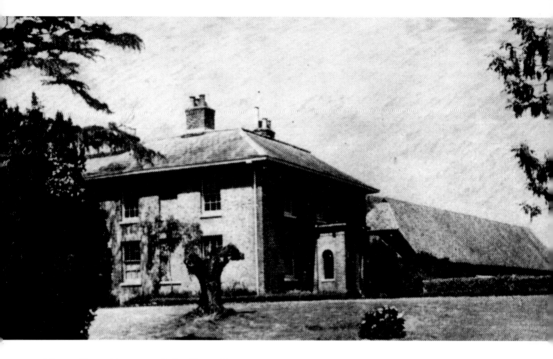

## Manor Farm House and the Great Barn, 1950

The Grade II listed farmhouse dates from the early nineteenth century This photograph is taken from a 1950s sales brochure for the buildings and surrounding land. They were bought by a farmer and continued to be used as a working farm into the 1970s. The farmhouse was converted to office accommodation in the late 1970s, but in 2012 its future use is uncertain.

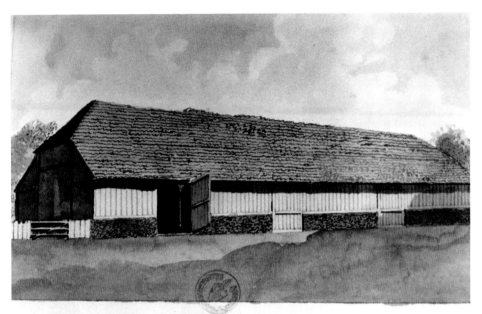

Great Barn at *HARMONDSWORTH* 1792, *the largest in the Kingdom.*

## The Great Barn, 1792 and 2004

The sheer size of the barn can only truly appreciated from the inside as seen on the following page; it is nearly 200 feet long, 40 feet wide and 37 feet high. That makes it the biggest medieval barn of its type surviving, and the ninth largest ever constructed in England.

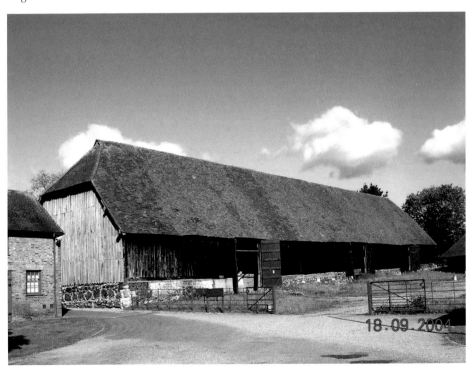

18.09.2004

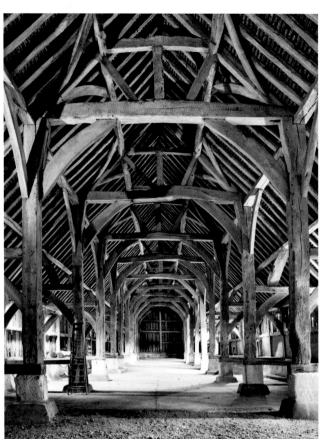

## The Great Barn

The interior of the Great Barn in all its glory. It has been likened to a cathedral in wood with a nave and aisles on either side. Its huge size is an indication of the former agricultural prosperity of the area which was killed off by decision to construct Heathrow airport on the most fertile soil in the country. The Friends of the Great Barn are seen here celebrating its acquisition by English Heritage in January 2012. For many years the future of the barn was uncertain and it was in the hands of a company that had no interest in the building other than as the possible source of profit if the projected construction of a third runway at Heathrow had led to its demolition, which at one time was a serious possibility. The group was formed in 2006 to seek means of preserving it for posterity.

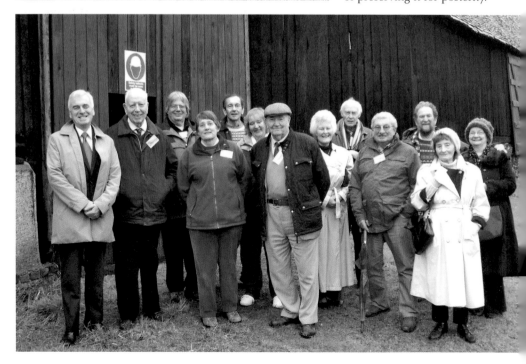

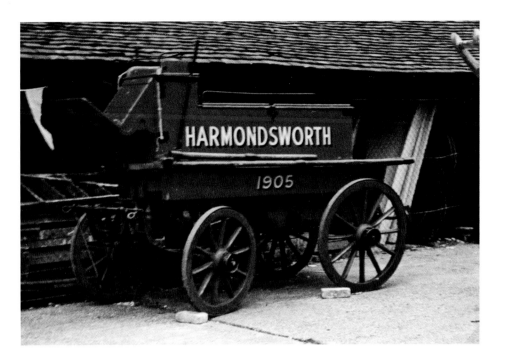

### Harmondsworth Fire Brigade

The Harmondsworth fire engine in a council store in 1970. The Harmondsworth fire brigade was a volunteer force that came under the jurisdiction of Harmondsworth Parish Council. The second-hand fire engine was purchased in 1879 and refurbished in 1905. It later came into the ownership of Hillingdon Council as the legal successor to the parish council, and through them was loaned to the London Fire Brigade (LFB) for display in its museum. Through a series of misunderstandings, the LFB sold the engine although it wasn't theirs to sell. Fortunately the engine was purchased by a local farmer who has renovated it and often puts it on display, as seen below during the Diamond Jubilee celebrations in June 2012.

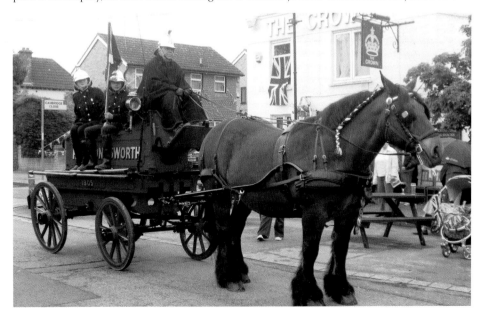

**Moor Lane, c. 1930 and 2009**

All of the houses in the picture except the two gabled buildings, seen in the distance in both photographs, were demolished in the early 1930s as part of a slum clearance policy. The houses seen in the picture below, which have replaced the old buildings, were built at the rear of their predecessors. When they were completed the old ones were knocked down and families moved from the old to the new.

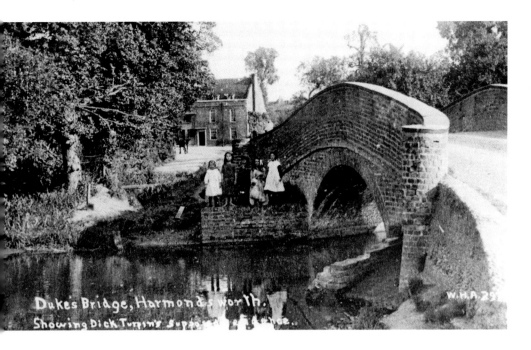

Dukes Bridge, Harmondsworth.
Showing Dick Turpin's Supposed residence.

### The Duke's Bridge in Moor Lane, Early 1900s

This is the first bridge of the three in Moor Lane and the only proper road bridge. It derives its name from the Duke of Northumberland's River, an artificial channel cut in the sixteenth century from the River Colne at West Drayton in order to supply water to the mills of Syon Abbey at Isleworth. Syon House is now the home of the Duke of Northumberland, hence the name. The attribution to Dick Turpin is incorrect – he never set foot in the area. Below we see the view to the north from the Duke's Bridge. The banks of the river are lined with pollarded willows (osiers), which at that time were used to make wicker baskets for use on the local farms.

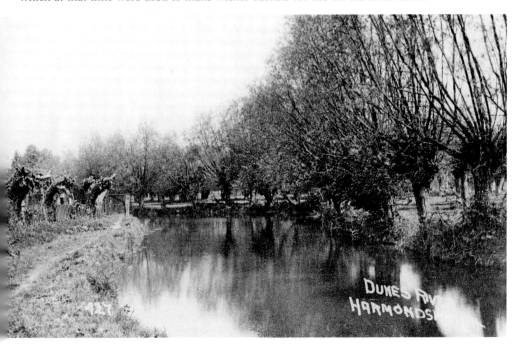

Dukes River
Harmonds...

75

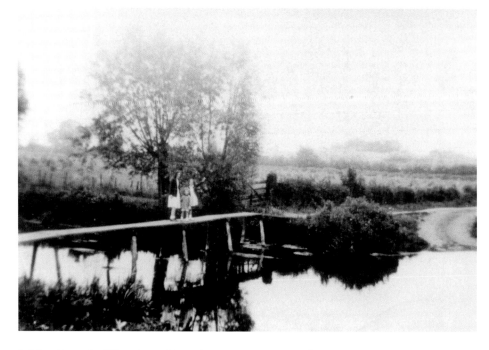

**Bridge Over the Wraysbury River, Moor Lane, 1938 and 1997**
The bridge was only three planks of wood in width and was identical in nature to the second bridge, which spanned the River Colne. The three children in the old image are Eileen Goodwin and her younger brother and sister. Taken from exactly the same position, the more recent image shows that the plank bridge has been replaced by one to meet modern safety standards. The tree in the background has grown considerably in the intervening years. Eileen Goodwin has become Eileen Rust and she is seen standing here with her daughter Fiona.

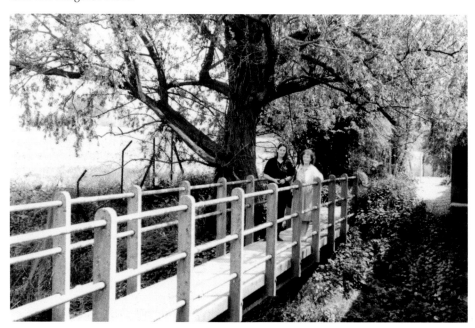

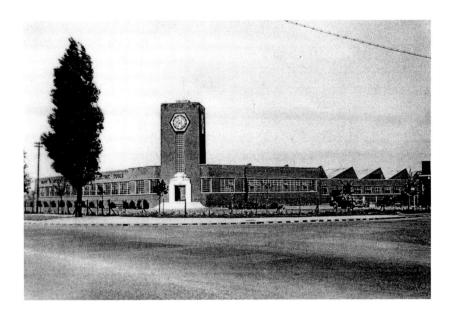

## Black & Decker, 1950 and 1967

This American company which makes small electrical tools opened a factory, built in red brick, at the junction of Hatch Lane and the Bath Road in 1940. The photograph above shows the factory in its original form; the tower and the poplar tree were considered to be a hazard to low-flying aircraft as they were in direct line with a south-east/north-west runway. In 1952, therefore, the tree was cut down and the height of the tower reduced. This was quite unnecessary, as the reduction in height was minimal and it was known at the time that the runway would soon cease to be used. The factory closed in the 1970s and its site is now a small industrial estate.

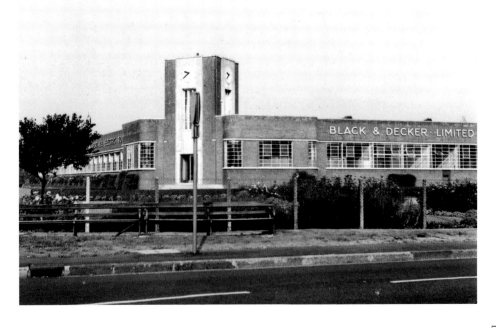

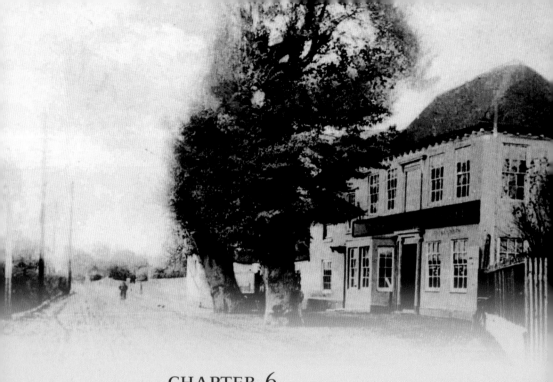

# CHAPTER 6

# Longford

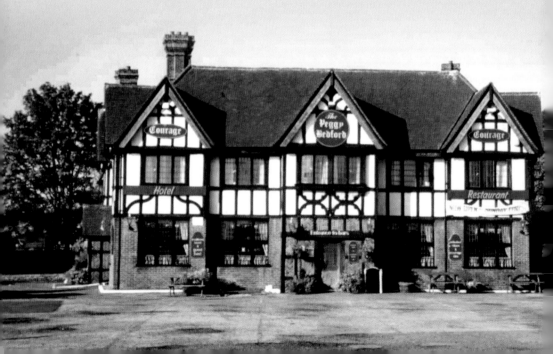

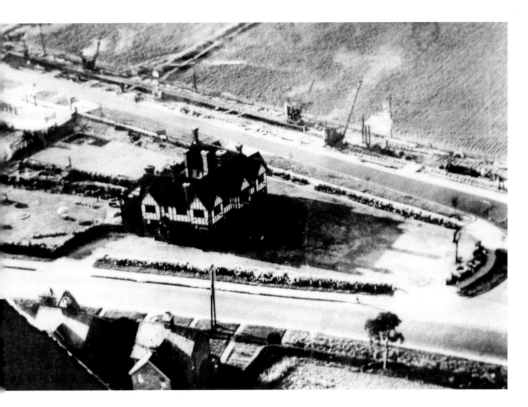

**The New Peggy Bedford and Colnbrook Bypass Under Construction, 1929**

On the previous page we see the original Peggy Bedford Inn in the early 1900s and the new pub and bypass in 1993, shortly before demolition. When the new pub was opened at the junction of the two roads in 1930, the former Peggy Bedford, which had stood about 200 yards to the west along the Bath Road, was closed. The new pub became a well-known local landmark, but it was demolished in 1995 to make way for a non-descript drive-in restaurant and a petrol station.

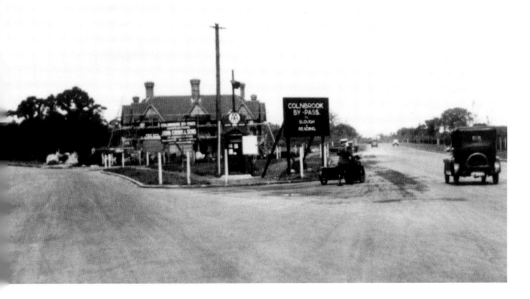

### The Stables and Phoenix Cottage, 1993

The original Peggy Bedford (formerly the King's Head) was T-shaped. The front half was destroyed by fire in the mid-1930s. However, the back half largely survived the fire, so a new front was added using material salvaged from the old building, to form this attractive private house. In 1993 it was well-maintained. Phoenix Cottage, on the right, was built after the fire also using materials salvaged from the old Peggy Bedford. Since the death of the last occupant, the Stables has become derelict, its windows boarded-up and its garden overgrown. In any other area such an attractive Grade II listed house standing in its own grounds would soon find an owner, but the proximity of the airport is a huge deterrent. Sadly this is the fate of many similar houses around Heathrow.

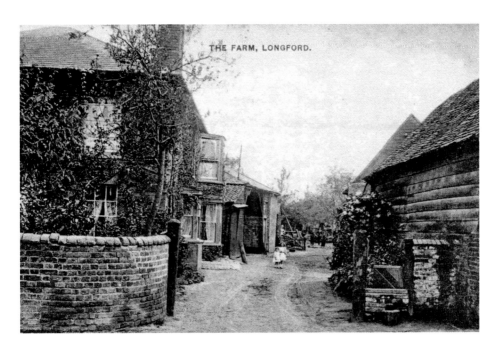

THE FARM, LONGFORD.

## The Farm, Longford, c. 1907 and 2012

The farmhouse dated from about 1830 and was the home of Henry John Wild who farmed as H. J. Wild & Sons. He came to Longford in the 1860s to help his uncle Richard Weekley, who had been incapacitated after being struck by lightning while sitting by the fireplace in Weekley House. The farmhouse was demolished in the 1960s and replaced with the office buildings seen here. These, like the many thousands of square feet of office accommodation around Heathrow built to meet a demand that didn't materialise, are currently vacant, with little sign of them being let any time soon. On the right is Weekley House, a Grade II listed building dating from the eighteenth century.

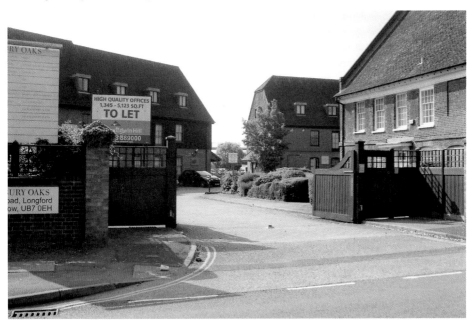

**Longford Baptist Chapel**

The plaque over the door gives its original name of Zoar Baptist Church. It was built in 1859 by Thomas Weekley on the side of one of his cottages. The building has been altered for conversion to residential use but the original plaque has been retained.

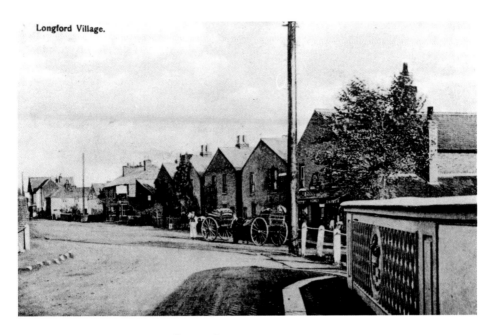

Longford Village.

## King's Bridge and Florence Villas, Early 1900s
The bridge dates from 1834 and gets its name from the fact that it is Crown property, as is the river, an artificial channel dug to provide water to Hampton Court Palace. The houses to the right of centre are Florence Villas; the one nearest to the bridge was the village store and post office. In the distance on the left is the King's Arms, one of Longford's two remaining public houses. Below, demonstrators gather outside the King's Arms in the mid-1990s. The demonstration was against the construction of a fifth terminal at Heathrow. The campaign was unsuccessful and the terminal opened in 2008. The roof of Weekley House can be seen to the left.

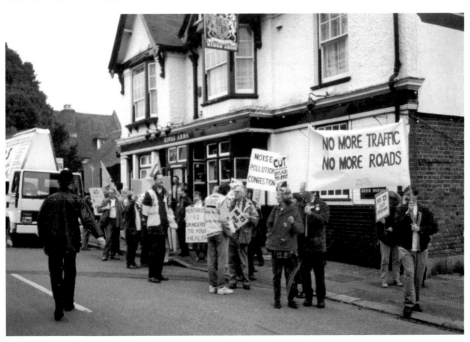

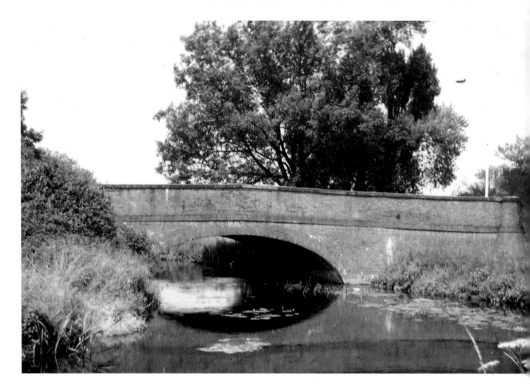

## Mad Bridge, 1960s and 1999

The bridge takes the Bath Road across the Wraysbury River, which at this point defines the western boundary of Harmondsworth Parish and also of the Borough of Hillingdon. The name is probably a corruption of 'Mead', although in view of modern developments in its vicinity it is very apt. In the newer image, commercial vehicles have been dumped alongside the River Colne in what would otherwise be an attractive riverside scene. This is in flagrant contravention of all planning regulations but is all too common in the area.

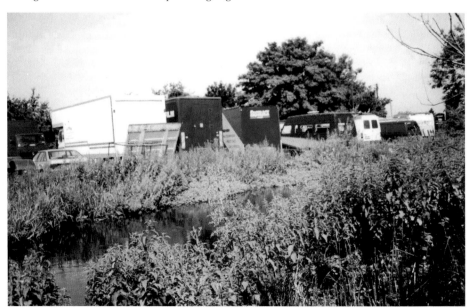

# CHAPTER 7

# Farming

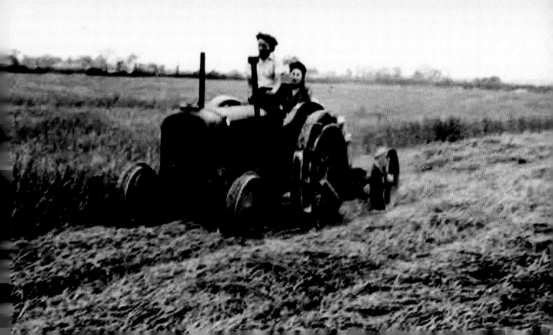

## Land Utilisation Maps of the Heathrow Area, 1932 and 1975

In 1932 (*above*) virtually all of the land around the villages was under intensive cultivation. The brown colour denotes arable land, the spotted blue areas are orchards and green denotes grassland. 1A refers to the fact that it was Grade 1 agricultural land of the highest quality. By 1975 (*below*) only the dark blue coloration (for arable land) and the green (for grassland) denotes land in agricultural production. In the intervening forty years the remainder has been taken over for urban uses, mostly connected with Heathrow Airport. Grade 1 land comprises less than 3% of the total land area of the UK. Was there ever such profligate waste of a valuable natural resource?

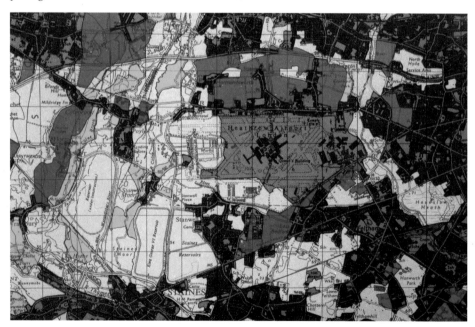

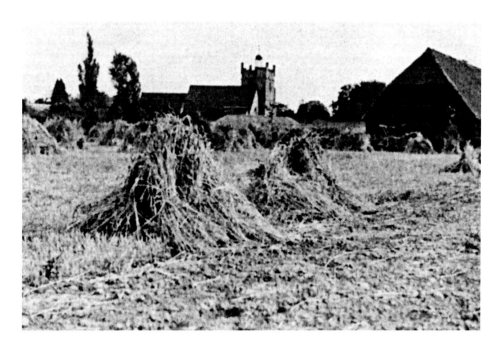

## Farming at Harmondsworth

The 1914 view shows a cornfield at Manor Farm, looking south with a view of the church and Great Barn. It is no longer possible to obtain a view from exactly the same vantage point. Instead we see the church and Great Barn looking east in 2009. Most of the land around the barn is no longer in cultivation, but the huge size of the barn gives a good indication of the formal agricultural prosperity of the area.

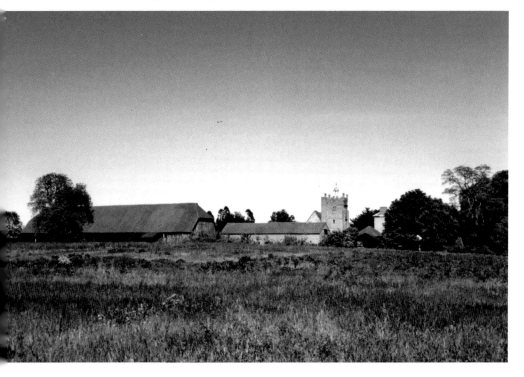

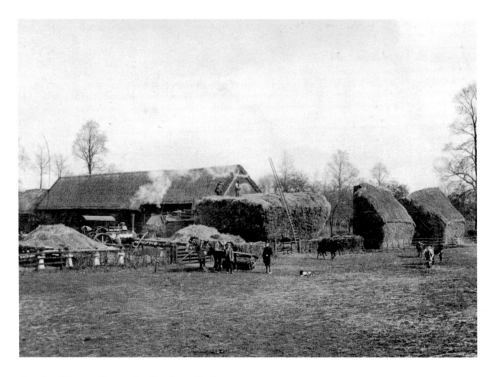

**Dawley Manor Farm, Harlington, Early 1900s**

In this early photograph we see steam threshing in progress. The same view is shown in 2012, below. Gravel has been extracted from the area but after restoration the field is still under cultivation. However, between the times of the two photographs the M4 motorway has been pushed through the area where the barn had once stood.

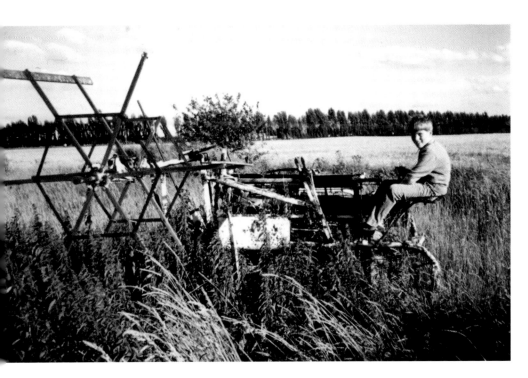

**Abandoned Reaping and Binding Machine in a Field Between Harlington and Sipson, 1972**
These machines represented a huge advance in harvesting when they were first introduced, as before then everything had to be done manually. However, they in turn have been replaced by combine harvesters, as seen below. The 1991 photograph was taken in the same field. Corn is now the principle crop grown on the remaining agricultural land in the area. It is not labour intensive and much of the land is owned by gravel companies that have little interest in agriculture.

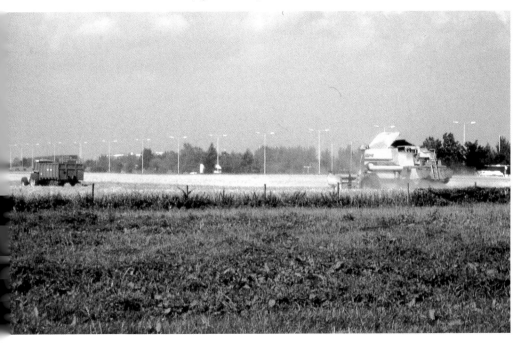

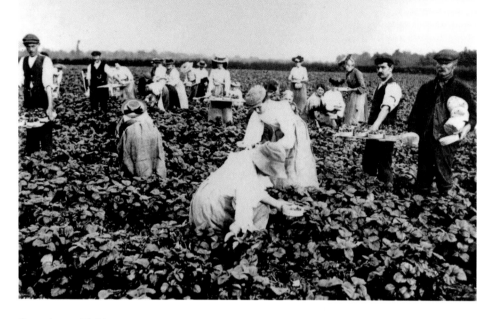

**Strawberry Picking, c. 1910**

A wide range of tree fruits and soft fruits were grown in the locality. This photograph shows a strawberry field. Fruit picking is a seasonal occupation and the female workforce came annually from Shropshire for the strawberry-picking season. They were known locally as 'Shroppies'. The field is now Imperial College sports ground in Sipson Lane, Harlington. It was bought by the college for this purpose in the 1930s.

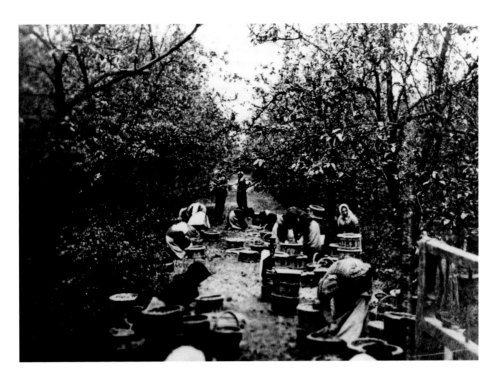

**Picking Fruit, Sipson, Early 1900s**

At the turn of the nineteenth century, fruit growing was one of the major industries of the area. In 1900 almost a third of the total area of Harmondsworth parish was occupied by orchards. Below we see a cherry orchard in Hatch Lane, Harmondsworth, in 1970. It was the last sizeable orchard in the district but it was grubbed up soon after this photograph was taken.

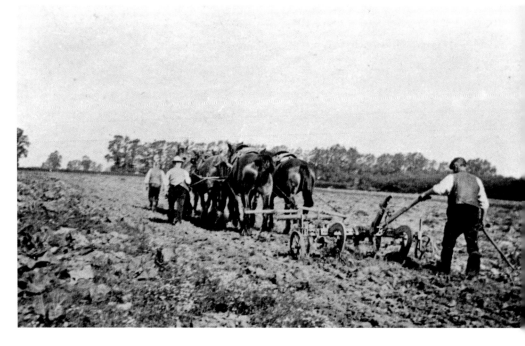

## Ploughing

Above is a plough team in the fields between Sipson and Harmondsworth in the early 1900s. The trees in the background denote the route of Holloway Lane. The M4 motorway now runs along the line followed by the plough team. Horse ploughing has all but disappeared but this farmer, at Home Farm, Hatch Lane, Harmondsworth, likes to keep up some of the old traditions. This area of land was previously occupied by the orchard seen on page 91.

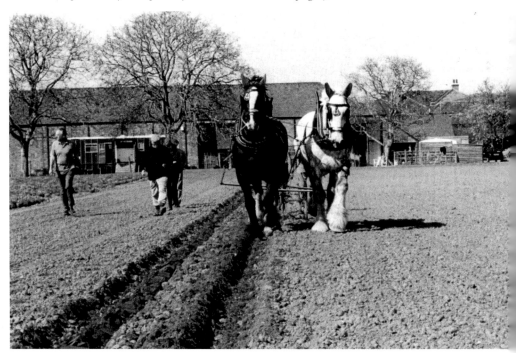

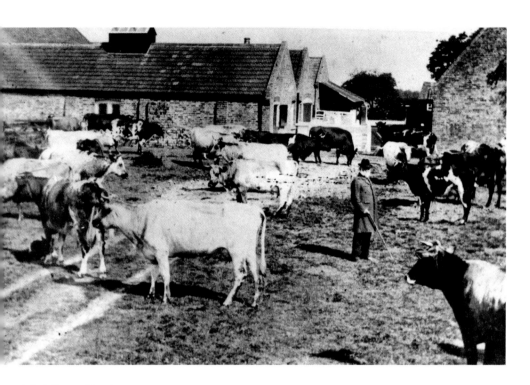

### Cain's Farm, Heathrow

Above, Charles Glenie inspects his dairy herd, while below we see the Cain's Farm Dairy milk float; both photographs date from the early 1900s. Milk floats such as this were the main means of delivery, as bottled milk was almost unknown. The milk was transported in churns, two of which can be seen in the float, from which the milkman measured out the milk into household jugs in pint and quart measures.

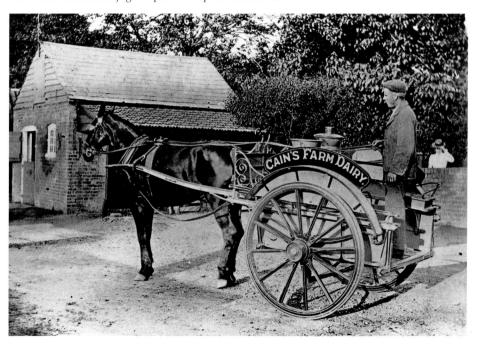

**Sipson Farm, Early 1900s**

This was the farmyard of Messrs. Wild & Robbins, by far the largest farming enterprise in the area. The site of Sipson Farm is now a housing estate known as Russell Gardens.

94

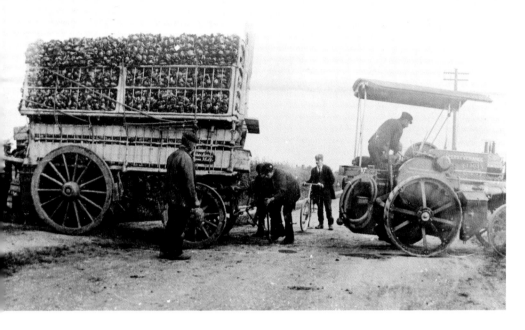

### Transporting Farm Goods

This scene in Sipson Road, near the site of the Holiday Inn hotel, dates from 1906. The cartload of cabbages has been horse-drawn to the field entrance and is being hitched to the steam wagon to take it to the farmyard. The steam engine has 'Perseverance 1903' written on its side.

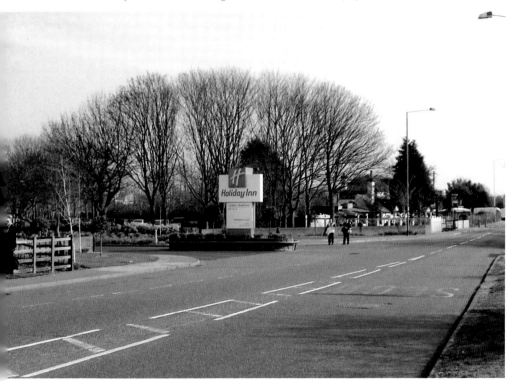

## The Impact of Gravel Extraction

Here we see a field under cultivation in Sipson Lane, Harlington, in 1978, and the same field a few years later. The extraction of gravel from the fields around Heathrow has greatly changed agriculture. Much of the land is owned by gravel companies and although restoration to agriculture is always imposed as a condition of planning consent, the land is never restored to its previous Grade 1 agricultural classification. As a result most of the land is given over to the growing of wheat, both before and after gravel extraction.

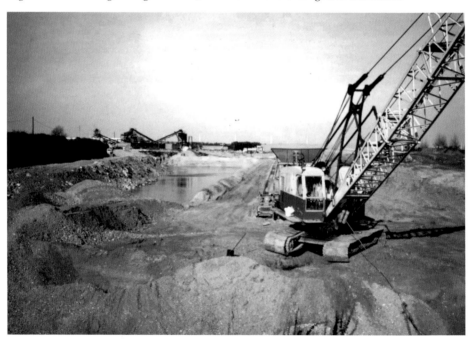